CDQ

CHARACTER DESIGN QUARTERLY

Image © Joakim Riedinger

CONTENTS

WELCOME TO *CHARACTER DESIGN QUARTERLY 22*

It's my pleasure to introduce another issue jam-packed with exciting and inspiring features from a whole host of excellent artists! We are delighted to welcome Max Grecke back to *CDQ* as the creator of this issue's striking cover art. As well as providing a captivating cover tutorial, Max chats to us about his varied career and how streaming to Twitch helped build a strong community of like-minded artists and fans.

This issue's tutorials feature a cavalcade of ideas, with a wide range of different styles and ideas that are certain to inspire. Greg Baldwin leads the charge with an in-depth look at how to build a stunning animal-powered robot, and Jackie Droujko brings to life a magical neon tiger. Brush up on your fundamentals, with a look at how shape language helps to create memorable characters with Melanie Tikhonova, and Joakim Redinger's crash course in showing motion in your designs.

With loads more tutorials, interviews with industry greats, and of course our compelling gallery feature, there's so much to get stuck into. Have fun and get creating!

SAM DRAPER
EDITOR

Image © Eirini Michailidou

BEHIND THE COVER ART
MAX GRECKE

Our eye-catching cover for this issue is the work of Max Grecke, a freelance artist from Sweden. Long-time readers of *CDQ* might remember him from all the way back in issue 1. We caught up with Max to find out what he's been up to since, why he's embraced streaming online, and how this issue's cover came together.

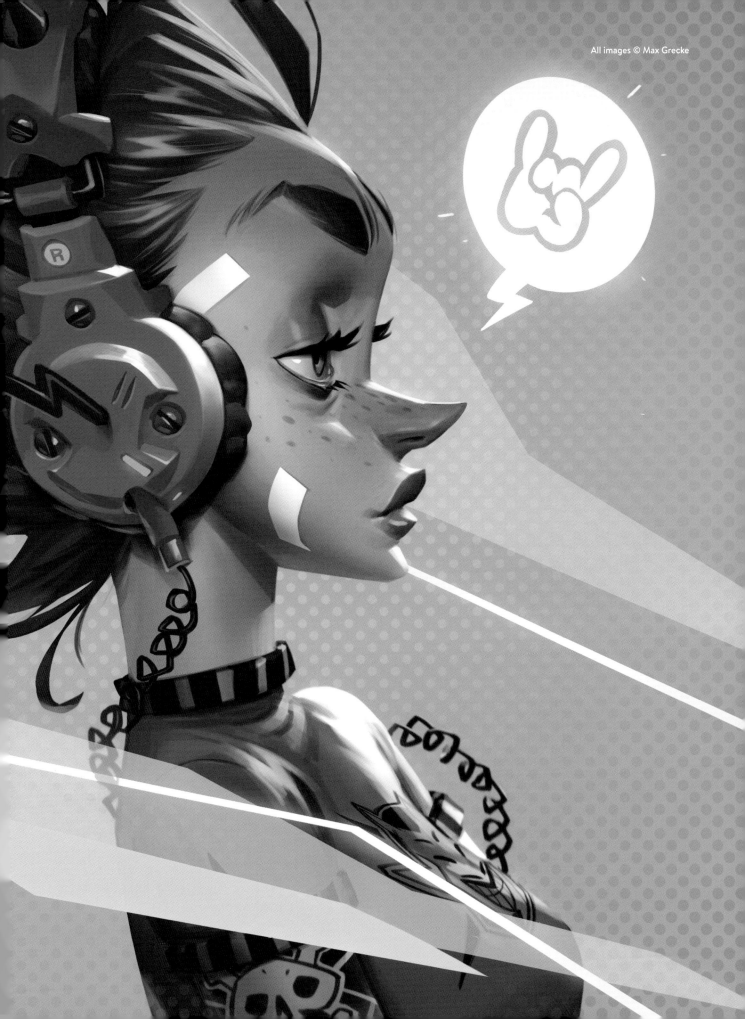

Hi Max, thanks for agreeing to speak to us. You featured way back in issue 1 of *CDQ* – can you tell us a little about yourself for our newer readers?

Hey *CDQ*! Yes, it's been a while, a lot has happened since then. Here's a little background for those who don't know who I am. I grew up in a small town in southern Sweden and have stayed there throughout my whole freelance career as a concept artist and illustrator. It's crazy to think that you can live anywhere on the planet and still work with some of the biggest companies in the industry, which I have been fortunate enough to do. Most of my professional work has been for games, such as *Hearthstone*, *Heroes of the Storm*, *League of Legends*, *Enter the Gungeon*, and a lot more.

I work mainly on characters, creating both concept art and illustrations, with a focus on fun shapes and stylized characters.

What are some of the most interesting projects you've worked on since we last spoke?

There have been so many amazing projects since our last interview. One thing I always wanted to do was to work on an animated movie or TV show, and recently I've managed to get a few gigs doing just that. I worked as a concept artist on the new 3D *He-Man and the Masters of the Universe* and also contributed some of the paintings featured in the show. I'm also working on the upcoming movie *DC League of Super-Pets*. Having worked in the game industry for so long it's been interesting

to work on animation – and a good learning experience, too. I think some of my rendering skills get more of a chance to shine in animation.

I also worked with Tito W. James on a short comic called *Slime Princess*, which was my first time trying my hand at that particular medium. That's the scary and amazing thing about freelancing, you never know what kind of project will appear in your inbox. Even if you don't feel experienced enough to work in a certain area, you have to trust the people who reach out to you – they want to work with you for the things you can do. Imposter syndrome is something I will always struggle with, but I've learned to deal with it and not let it affect my art as much as it used to.

"ONE THING I ALWAYS WANTED TO DO WAS TO WORK ON AN ANIMATED MOVIE OR TV SHOW, AND RECENTLY I'VE MANAGED TO GET A FEW GIGS DOING JUST THAT"

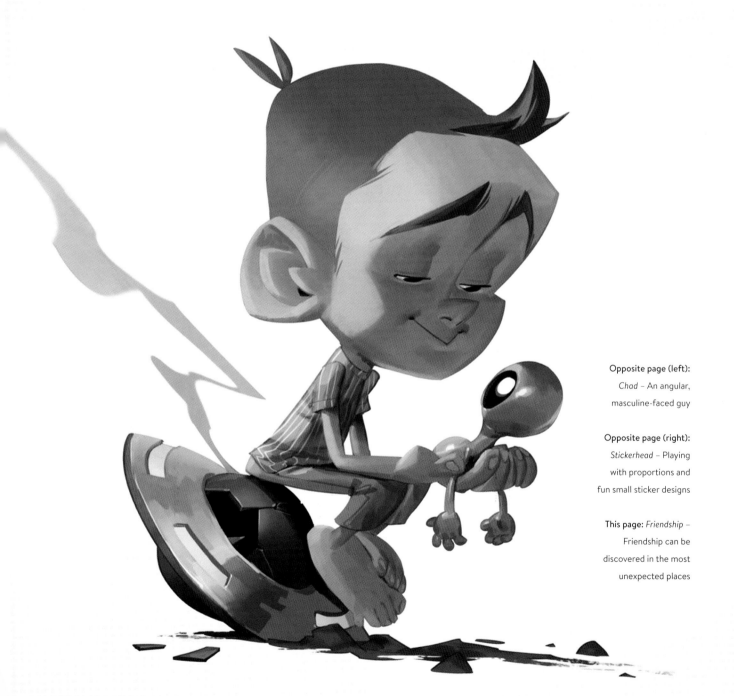

Opposite page (left):
Chad – An angular, masculine-faced guy

Opposite page (right):
Stickerhead – Playing with proportions and fun small sticker designs

This page: *Friendship* – Friendship can be discovered in the most unexpected places

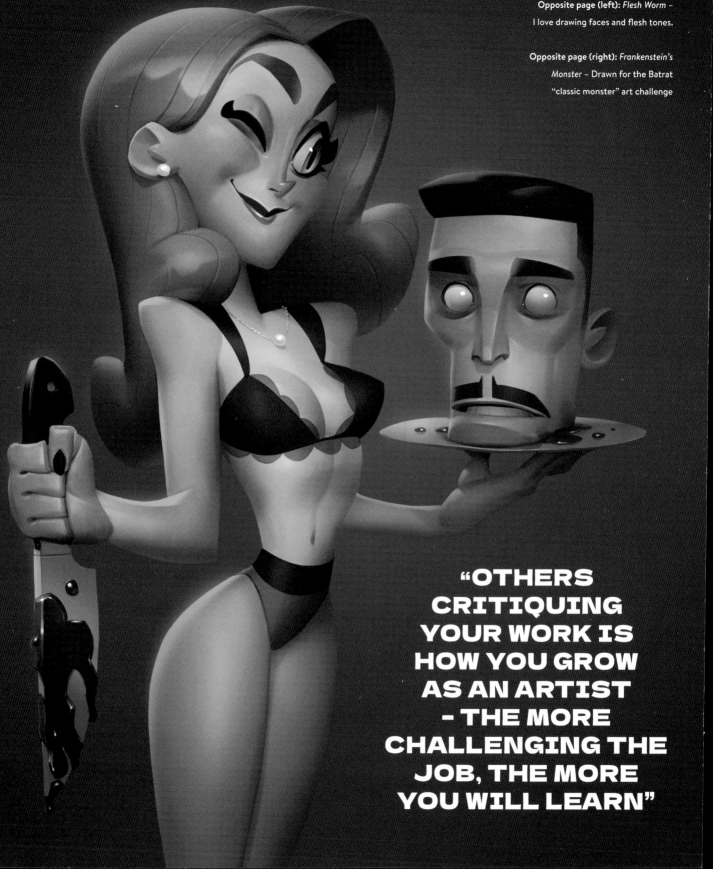

"OTHERS CRITIQUING YOUR WORK IS HOW YOU GROW AS AN ARTIST – THE MORE CHALLENGING THE JOB, THE MORE YOU WILL LEARN"

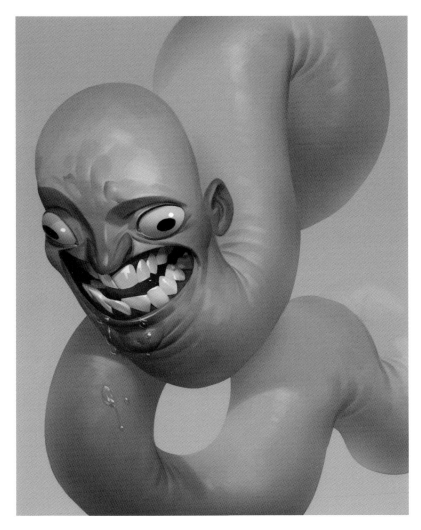

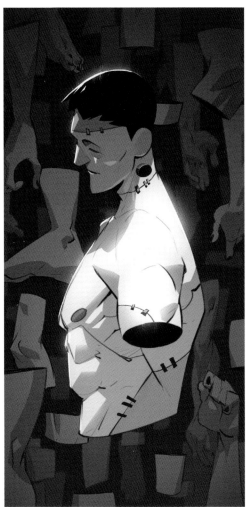

As you mentioned, you've freelanced for many of the industries biggest companies. Are there big differences in how these places operate, and which working methods have you found most successful?

Having worked in the game industry for about seven years, I've had the chance to see how several different companies work with freelancers. The bigger companies are dealing with loads of freelancers on a daily basis, so they usually have a very structured workflow in place. I think it can be easy to feel overwhelmed by the big guys because you feel like a very small piece in a much larger puzzle. That's where having the experience of working with many different people is useful; I know what I'm worth and have the confidence to back that up, too. It can be tricky when you're first starting out and you don't have that experience.

No matter the size of the company you're working with, I think the most valuable thing they can do is show that they appreciate you and the work you do, while also giving valuable feedback that makes you question every artistic choice. Others critiquing your work is how you grow as an artist – the more challenging the job, the more you will learn.

How, if at all, has your approach to character design changed since you featured in *CDQ 1*? Is there anything you would do differently now?

To be honest, I'm still happy with what I did back then, and my process is still pretty much the same. Although there were many interesting choices I wouldn't make today. I feel that I have a bigger visual library of things to inspire me these days. One thing I've been trying to push myself to improve on is storytelling, having a clear narrative and mindset of the character defined while drawing them. I don't want to just use colors and clothing to push the story, but also shape language and the poses and expressions of the character. This more rounded approach is one of the differences I've noticed between game character concepts and characters for animation.

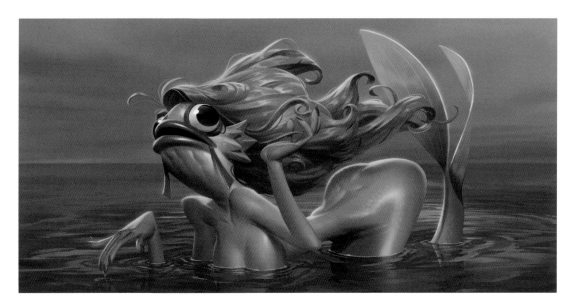

This page: *Mermaid* – A piece created for Mermay

Opposite page: *Mirror Girl* – Stylization study based on a photograph

We noticed you stream regularly on Twitch, chatting with the community while you work. What do you get out of this interaction, and what do you hope the audience gets from it?

I started off watching other artists on Twitch and I really fell in love with the community aspect of it. Streaming gives you the opportunity to directly interact with your audience. The same people will pop into chat while you stream, and you can get to know them over time. Being a freelancer and working from home all day, I definitely missed socializing – yes, even as an introvert! It was very hard at first, dealing with social anxiety and just not being very comfortable being in front of camera and having people watch me draw. After a while, though, the anxiety and dread completely flip round, and streaming helps improve your social skills instead.

Starting to stream and creating a Discord server (the Batrat Church of Art) was probably one of the best choices I've made in my art career. We've built a community of like-minded people, passionate about art, sharing stories live over streams, and completing art challenges and projects together through Discord.

What advice do you have for young artists looking to break into the industry?

The sooner you know what area you want to break into, the better. Try and focus and really practice one thing, for example character art, illustration, concept art, or environment art. If there's a specific company you want to work for, practice the art styles that they tend to use. This was kind of my goal, originally, as I wanted to work for Blizzard. I knew that if I worked hard it could be possible, so I filled my portfolio with examples of my work that fit with the style of *World of Warcraft*. While working toward my dream I had to make money, so I did any kind of freelance work I could land along the way. I was glad for this experience as it made me realize I enjoyed working on all kinds of different projects and not just on one style. So don't be afraid to follow a different path if other opportunities present themselves. The work I do today my younger self wouldn't possibly be able to imagine.

Did your large social-media following develop gradually over time, or was there one big event that changed things? How do you get your work noticed?

I'd say it's a combination of both growth over time and one-off big moments. Making fanart and images that are relevant at any given time is usually a safe ticket to gain more traction, or if you're lucky enough to have someone even bigger share some of your stuff. If that happens, make sure to use that moment – be extra active on your socials and catch those people that fall onto your page.

Recently, there's been a lot of things changing with social-media platforms regarding how their algorithm works and how it rewards people. I mainly use Instagram and it's been sad to see how just posting pictures isn't cutting it anymore. If you want to be successful on there now you have to make multiple stories, reels, and videos of your work. So, I think gaining traction is much more work now than it was before.

Making things viral and popular might get you better metrics, but I don't think it's always the right way forward for your artistic growth. Draw things you want to draw and don't just make stuff for other people. With time, as your ideas get better, you will find an audience that appreciates your craft.

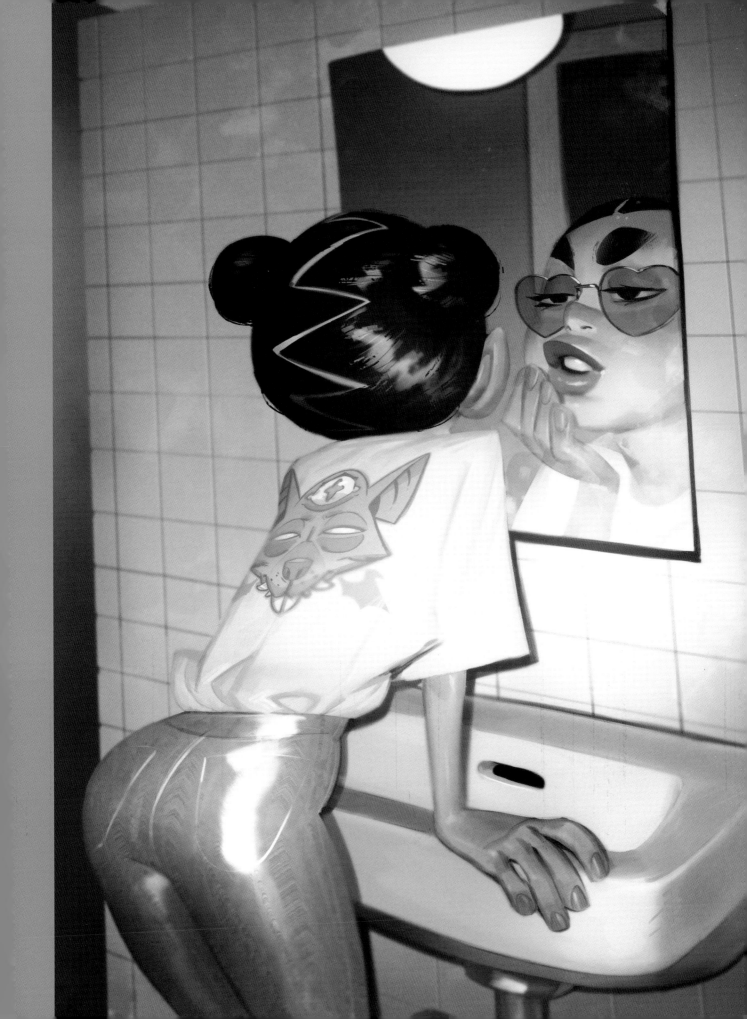

CRAFTING THE COVER

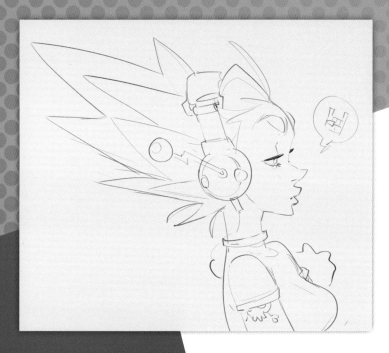

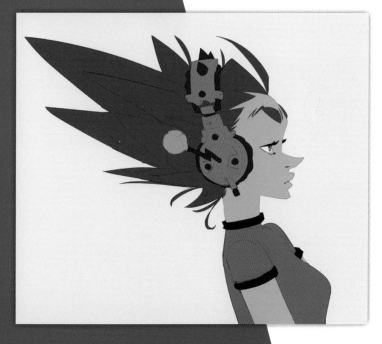

SHAPING UP

I start by exploring shapes to find an appealing composition that fits the format of the *CDQ* front cover. My initial idea is to make a fun portrait with a few interesting accessories and details. Even at this early stage, I try to keep my sketches as clean as possible to avoid having to redraw too much line art later.

REFINING THE LINES

Instead of redrawing my initial design, I like to sculpt and reshape the first sketch, cleaning up parts and nailing the shapes that I'm looking for. I make a base layer which I'll later use as a masking tool, and separate each part of the character into their own layer. Keeping edges clean and crisp also helps with masking.

LIGHTING THE WAY

Next, I need to figure out the lighting and how I want to display the forms and volumes. I decide to go for a pretty basic light source at this stage to show off the design effectively. However, I want to introduce a secondary colored light source later on in the process – it's important to plan for that already. The original light was picked specifically for the color and contrast I'll be adding later on.

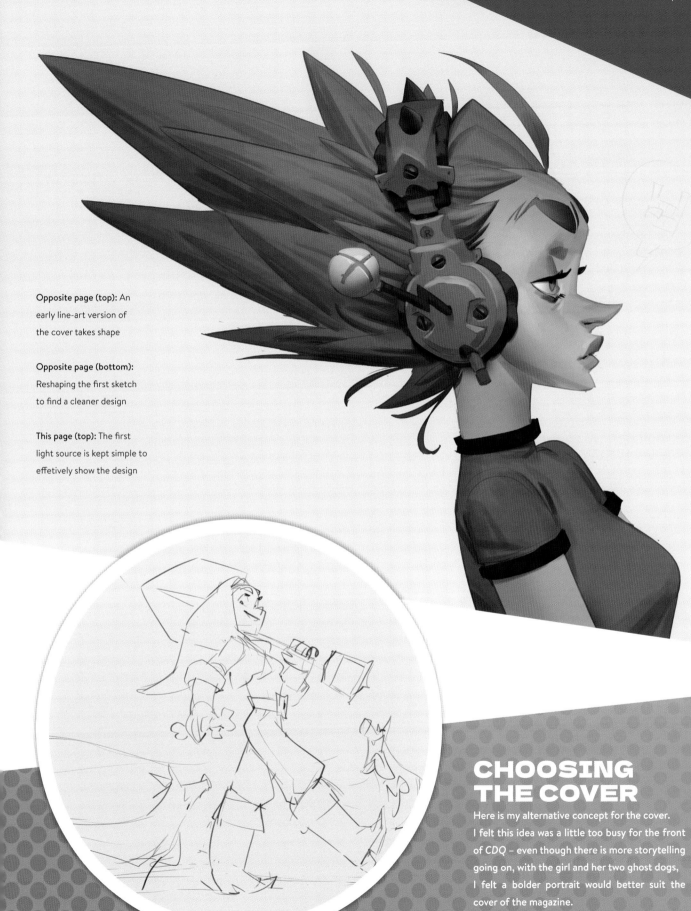

Opposite page (top): An early line-art version of the cover takes shape

Opposite page (bottom): Reshaping the first sketch to find a cleaner design

This page (top): The first light source is kept simple to effetively show the design

CHOOSING THE COVER

Here is my alternative concept for the cover. I felt this idea was a little too busy for the front of CDQ – even though there is more storytelling going on, with the girl and her two ghost dogs, I felt a bolder portrait would better suit the cover of the magazine.

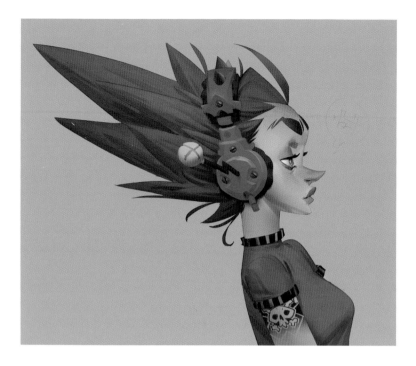

A COAT OF PAINT

I try to get my black-and-white values as accurate as possible before adding the color layer on top. Sometimes, the result isn't quite what I imagine it will be – if this is the case, I'll add a Multiply or Overlay layer on top to get the look I'm after. At this point, I'll also add any color variations, subtle shifts, or patterns, if I think they're needed.

BALANCING DARK AND LIGHT

Now I start to play around with the contrast and value range, darkening the whole character to make the secondary light source really pop and stand out. I also use a darker Multiply layer to lighten the focal point further, pulling the viewer's eye toward the character's face. At this stage, I start to see how some of the materials stand out from one another, like the headset and the speculars hitting the edge of them.

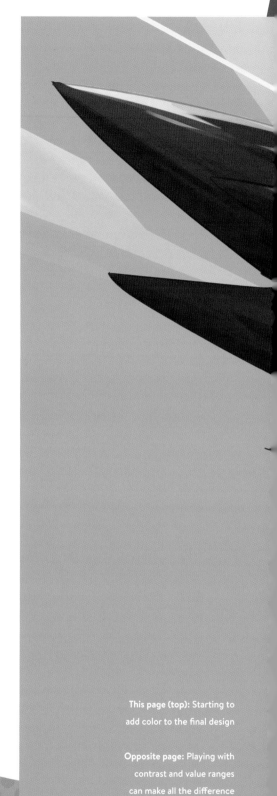

This page (top): Starting to add color to the final design

Opposite page: Playing with contrast and value ranges can make all the difference

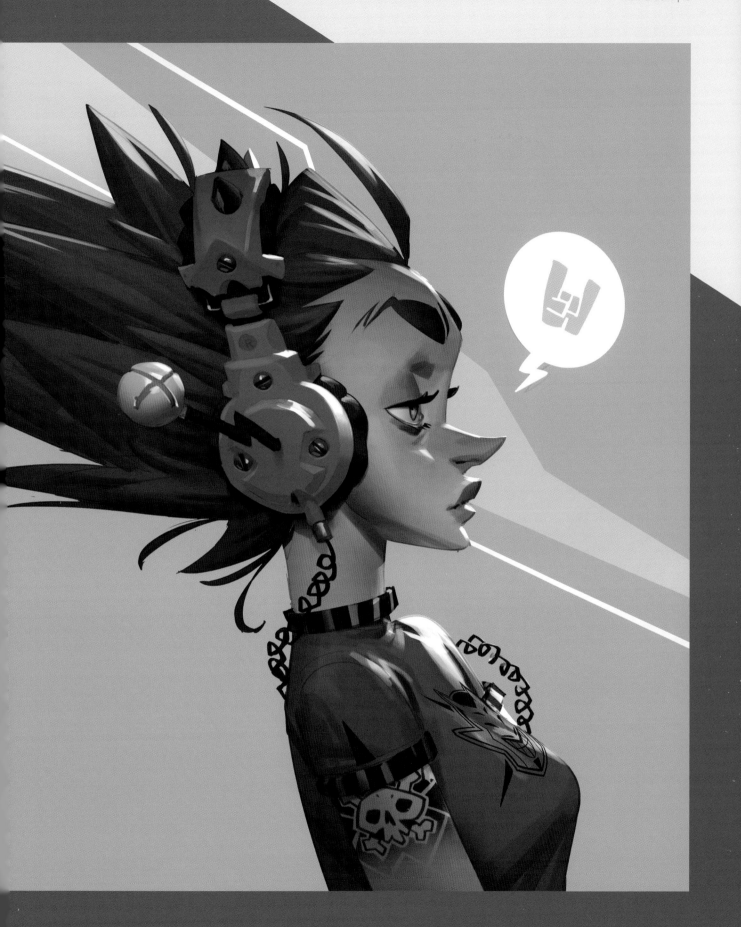

"THIS IS WHERE BEING NEAT AND TIDY IN THE PREVIOUS STEPS PAYS OFF"

THE FINAL POLISH

Now I can stop experimenting with contrast and colors and begin merging the pieces together and start the rendering. This step usually takes around 50% of my process time, rendering and tightening up details to make the piece look polished. This is where being neat and tidy in the previous steps pays off, making this step as smooth and fast as possible.

These pages: Adding the final polish takes time, but it's worth it.

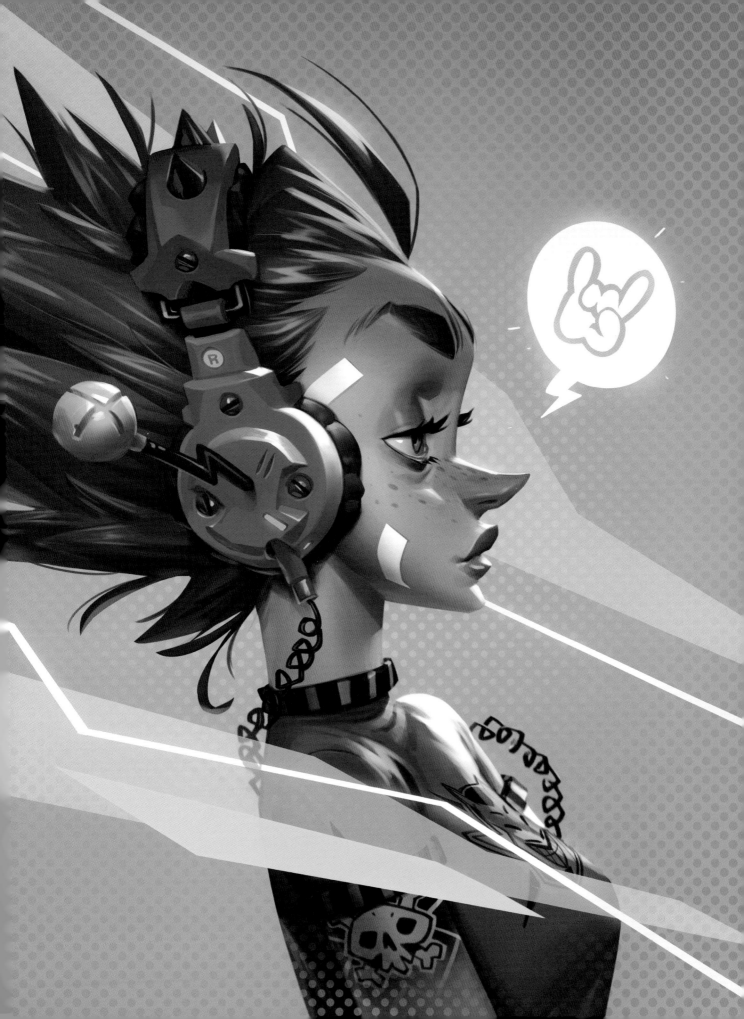

SPLENDOROUS SHAPES

MELANIE PEÑALOZA TIKHONOVA

Every aspect of a character's design works together to create a unique personality. In this article, we will talk about "shape language" – how using shapes can define who a character is, and tell their story. We will create three characters with variations for each one, to see how different shapes influence their design. I will be using a paper cut-out method first, and then move to a digital format. Let's get started.

CUTTING OUT CHARACTERS

Start by grabbing paper and drawing all kinds of random shapes – anything you can imagine. Then cut out the shapes and paste them onto a separate piece of paper, take a picture, and bring them into a digital format, such as Photoshop or Procreate.

THE SILHOUETTE METHOD

A similar method to the paper cut-out technique used in this article is the silhouette method. You can begin creating characters by blocking out body types with a single fill, then lowering the opacity to sketch on top of them.

EXPLORING THE SHAPES

Think about your characters' personalities and build a base from the shapes you have. In general, circles feel friendly and approachable, squares feel sturdy and grounded, and triangles feel energetic and dangerous. When mixed together, they can create more complex personalities. Add more information to your base shapes, such as suggestions of costumes and limbs. Explore and see what you can come up with – there are no wrong answers at this early stage.

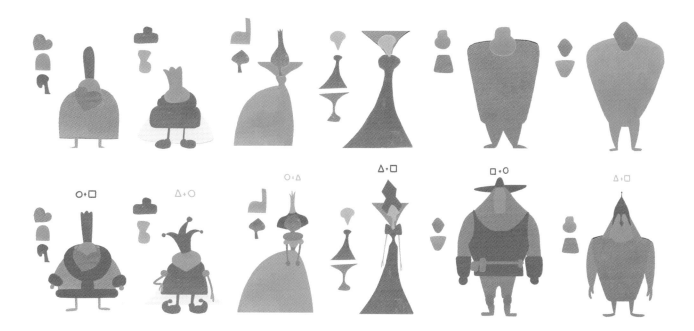

SHAPES BECOME SKETCHES

Use your base shapes as a guide and begin to sketch out your characters while thinking about their personality. Change their pose and proportions, and exaggerate shapes as much as you like. You can also adjust the major shapes used if you want to convey a different personality. Once you are happy with your designs, it's time to start adding line and color to your characters.

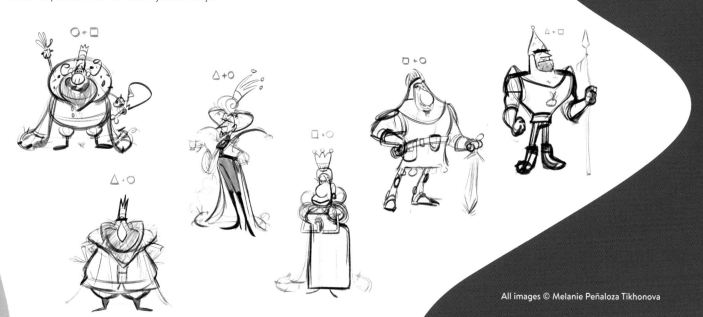

THE KING

The main shape used is a circle to demonstrate the friendly, approachable, and silly nature of this king. There is a hint of a square in his design to convey his royal status.

In this design, the triangular shapes give the king a more devious look, while the circular shapes soften his character, making him come across as a little inept.

THE QUEEN

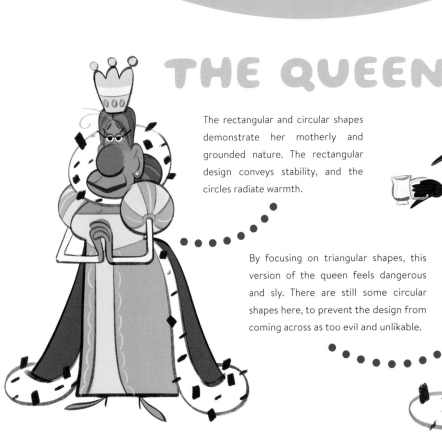

The rectangular and circular shapes demonstrate her motherly and grounded nature. The rectangular design conveys stability, and the circles radiate warmth.

By focusing on triangular shapes, this version of the queen feels dangerous and sly. There are still some circular shapes here, to prevent the design from coming across as too evil and unlikable.

THE KNIGHT

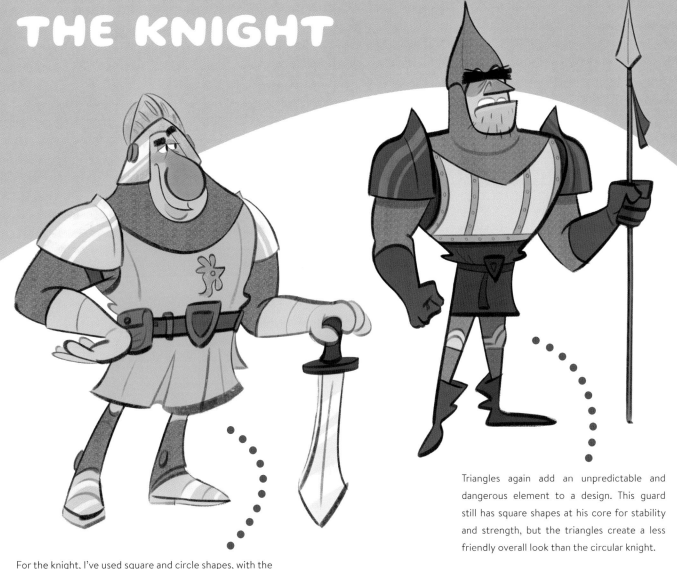

For the knight, I've used square and circle shapes, with the emphasis on the squares. This is to show his strong and sturdy side, with the circular elements added to soften the design, making him seem friendly.

Triangles again add an unpredictable and dangerous element to a design. This guard still has square shapes at his core for stability and strength, but the triangles create a less friendly overall look than the circular knight.

"TRIANGLES ADD AN UNPREDICTABLE AND DANGEROUS ELEMENT TO A DESIGN"

DRAW EVERYWHERE

A great way to create your characters is by observing life. Sketch in the café, draw at the zoo – look around your surroundings for shapes and objects you can turn into characters. Try new mediums, carry around a mini sketchbook, and just have fun!

THE TIGER'S TALE
JACKIE DROUJKO

Finding the perfect colors to emphasize mood and narrative is always an exciting challenge. Often, we think of colors as an afterthought, but I find colors to be as important as shapes and story. In this tutorial, I will show you my process, from developing an idea, working through many iterations before settling on a concept, and how I create a full and balanced composition – all while using color as the center of my design.

Final image © Jackie Droujko

AN IDEA EMERGES

Let's start by brainstorming an idea for a new illustration. How do you want the piece to feel? What story do you want to tell? There are millions of directions a new painting can go, so I create a word map of all the words that come to mind when I think of what I would like to draw. I want to portray a gentle and magical feeling, so I consider how I can represent those qualities in my drawing. For a gentle look, I can incorporate round shapes and not use harsh angles, and for magic I can use vibrant and unrealistic colors.

THUMBNAIL CONCEPTS

The next step is to create thumbnails of the composition. These thumbnails can be as rough as you want – the idea is to suggest where each character will be in the drawing, as well as representing the basic shapes you want to emphasize. Keep in mind the silhouette for a clear design. I know I want a central composition of three companion wolves surrounding an ethereal woman. A large wolf looming above the character will exude a feeling of protection. I want the ground visible in the illustration so the environment in which the characters live can further tell the story.

SKETCHING THE PACK

Sketch out your favorite thumbnail idea while keeping the moodboard in mind. I draw a woman sitting with a pack of wolves, keeping her in the center of the illustration so she feels safe, tucked within the pack. I keep the shape designs round to convey the idea of gentleness, and the details low to maintain a sense of mystery around the animals. Are they real or part of her imagination? What are they all looking at? How could she have tamed wild animals? Is she a type of magical creature herself? I want the audience to have all these questions in mind when looking at this illustration – this will mean I've succeeded in creating mystery within the story.

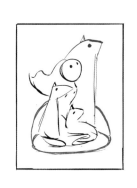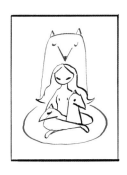

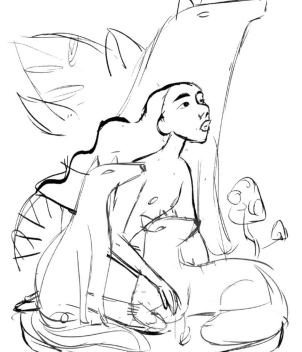

This page (top):
Put your thoughts on the page with a mindmap

This page (middle):
I explore different ideas before committing to a sketch

This page (bottom):
Sketch out your strongest idea

Opposite page:
Creating a rough color pass of my concept

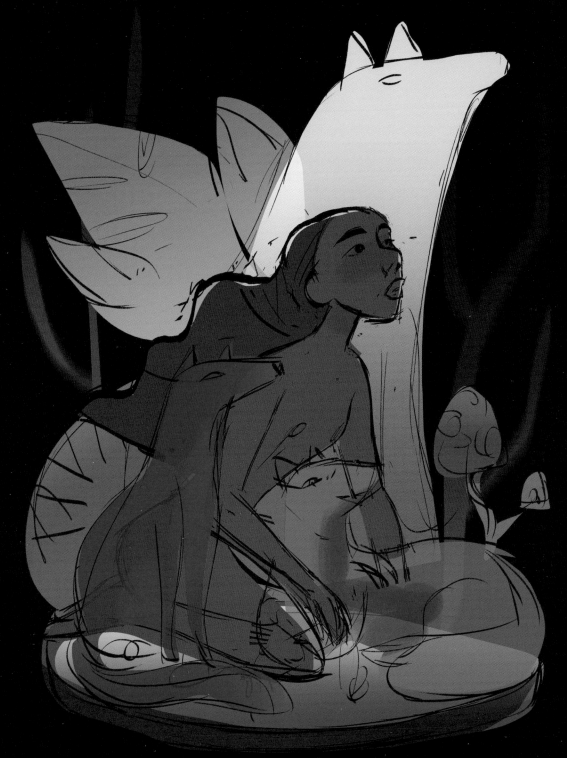

COLOR AND MOOD

I want color to be the most alluring part of this illustration, so I add some rough ideas before continuing with the design. Against a black background, these unnatural colors feel so much more vibrant and ethereal.

Using blues and yellows for the wolves adds to the unnatural feeling I'm trying to portray. The animals feel ghostly as they are semi-transparent. The concept feels magical at this point – a naked woman with her wild

companion animals isolated on the black page. Now I need to define the lines to get a stronger idea of the final drawing.

DETAILED SKETCHING

I begin sketching more detailed wolf companions, because I know the lineless style I'll be using is already so simple that I will need a more structured design for the wolves. After trying this more detailed approach, I realize the animals don't fit with the soft and tropical mood I'm going for – they're too angular, and wolves typically represent threat and danger. Art is an evolving process – don't be afraid to work through many ideas before reaching the final design.

> "I MAKE SURE ALL THEIR HEADS ARE AT DIFFERENT HEIGHTS AND THEIR POSES DIFFER TO CREATE VARIETY AND INTEREST IN THE COMPOSITION"

RE-EVALUATING THE CONCEPT

Instead of wolves, I decide to go with tigers – they fit my requirement for tropical animals that I can design using round shapes, and their stripes will add a playful design element. I draw two cubs to really emphasize the gentle nature of the illustration, with a large adult encompassing the other characters, as if protecting them. I make sure all their heads are at different heights and their poses differ to create variety and interest in the composition. I'm happy with this thumbnail as the basis for my final composition.

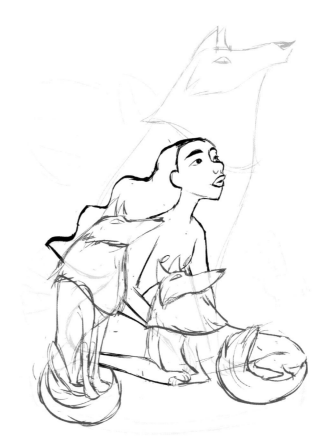

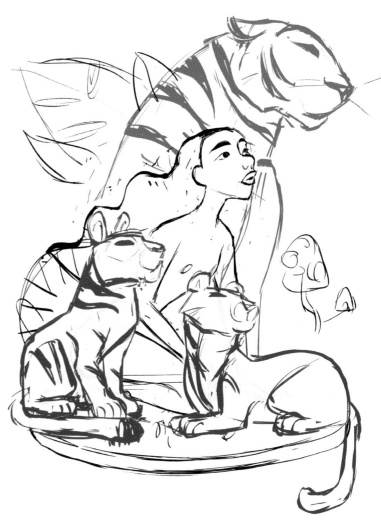

This page (top):
Adding detail to the sketch creates a structured design

This page (bottom):
Creating a new sketch based on my re-evaluated idea

Opposite page:
A new concept needs a new color palette

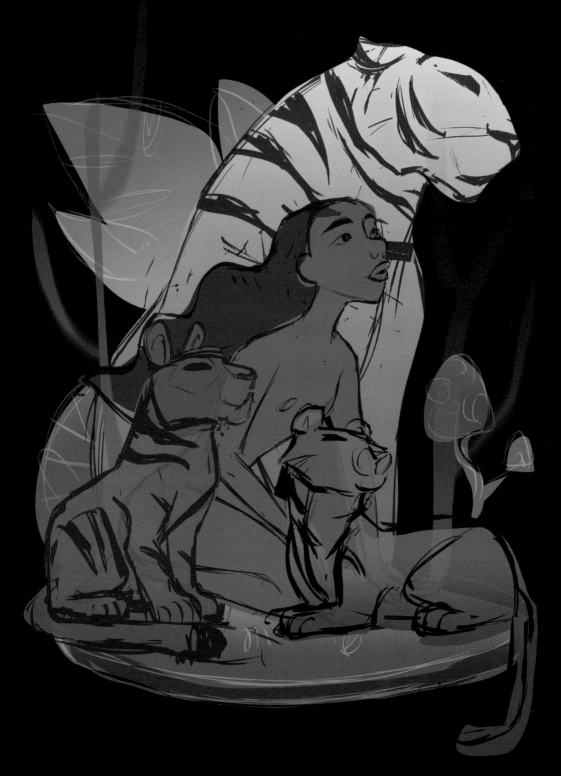

COLOR CHANGE

After changing the animals I'm using, I can see that my color choices could do with being more unified. I use the complementary colors blue and orange on the woman and main tiger to make them the focal point of the image.

I intentionally paint the tigers with warm colors and use cool tones for the woman and background elements to create contrast throughout the design. I don't want the plants and ground to feel too far removed from real

life, so I keep their color as shades of green. I want the woman to feel unreal and magical, so I choose a very unrealistic and monochromatic color palette for her.

REPLACING THE FACE

Next, I explore different variations of the woman's face. Her expression will communicate her story, what she's feeling, and how the audience should feel. This is a great opportunity to consider my character's mood – is she sad? Hopeful? Consider your character's thoughts when drawing their expression. The face on my initial sketch is too realistic for the lineless style I will be using, so I explore different levels of detail and shapes. Some designs are more angular, some rounder, some simpler, and some detailed. I choose the design that has a good balance of angular and round shapes, as well as the expression that matches the mood I'm trying to convey.

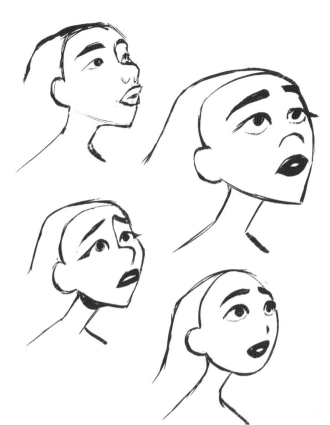

This page (top):
Exploring different facial expressions and shapes

This page (bottom):
Incorporating both straight and curved lines creates an appealing design

Opposite page (top):
Blocking in the silhouette of the additional characters

Opposite page (bottom):
Finalizing the base colors of the characters to complement the focal point

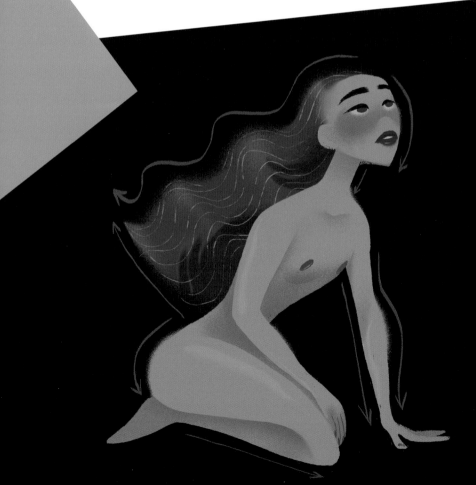

LINE DESIGN

Now we can work on developing the main character, incorporating the round lines and shapes that will create a gentle mood. It's important not to forget to offset the curved lines with straight ones. But how do you keep a rounded character design while also using straight lines? My trick is to ever-so-slightly curve those straight lines so they still leave a round impression when looking at the overall character. Creating your first character sets a precedent for how you will approach the style of the rest of the illustration, so be sure you're happy with how they look.

BLOCKING THE BEASTS

I block in the tigers' silhouettes from the sketch to make sure the composition is strong. I'm also looking to clean up any issues that might weaken the design later on, such as tangents, a bad combination of straights and curves, or characters that don't appear properly planted on the ground. In this step, I usually try to simplify the shapes as much as I can to improve readability – it's very important that the viewer can instantly identify what they're looking at. I intentionally separate the tail, ears, and snout from the rest of the design to avoid overlapping groups and further clear up the shape of the silhouette.

COLORFUL CORRECTIONS

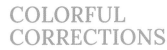

Next, I block the colors for the tigers. I have my rough color palette from earlier to work with – I need to refine and adjust those colors for the final image. This means flipping between CMYK settings for print and black-and-white settings to check if the values are correct. To ensure the woman in the middle stands out, I'm keeping the animals' warmer colors to contrast her cooler look. When choosing your color palette, the design shouldn't be the only thing drawing the audience's eye to the focal point – color is just as important. There's a lot to consider, as all these decisions can quickly change the meaning of your piece. Is your drawing looking grimy and sad? Perhaps it's best to use less saturated colors. Or maybe you want your character to exist in a more realistic world – natural colors will help ground them in reality.

SHAPING THE DESIGN

Without lines, how do you separate shapes within a character? With blocks of varying colors and contrasts. Creating interesting shapes within the character's design is just as important as their silhouette. I always make sure the shapes and sizes within my characters have variety – this adds dimension and volume to a design. Always try to avoid repetition to keep characters looking interesting. Follow the inner shapes of your design creating an invisible line and make sure that they all connect fluidly to one another. This is my technique for creating a harmonious character design.

DISSOLVING AND BLENDING

By setting a soft round brush to Dissolve you can create a textured custom brush. I used this brush to create soft silhouettes. This creates a magical effect – I imagine if this illustration were animated, the grain would cycle in a really cool way. I discovered this technique during the creation of this piece!

TIGER BURNING BRIGHT

I add stripes to the tigers and the piece is really starting to come together. Using similar colors to those surrounding the tigers creates harmony throughout the design, keeping each element connected. I want the texture of the animals to feel fuzzy, so I keep as much grain in the design as possible. I add subtle transparency around their faces to accentuate the magical nature of these creatures and a ground plane in preparation for the next step.

Opposite page (top):

Harmonizing shapes
leads to a fluid design

This page (top):

Adding stripes and details
to the tigers for a more
interesting design

ALWAYS CHECK YOUR VALUES

Don't forget to check your values by looking at your piece in grayscale. This is a great way to see if there is enough contrast in your piece for your audience to clearly read the drawing. If some areas are nearly indistinguishable from others, make sure to play around with the value by adding Multiply and Overlay layers before finalizing your colors.

BUILDING THE BACKGROUND

When creating the background, I use my sketch as a starting point but give myself liberty to improve upon it. I create two trees to mimic the complexity of the tigers' stripes and round out the edges to a circle to simplify the design. The other foliage complements the focal point without drawing the viewer's attention away from the main character. The background is mostly green to very clearly ground the scene in a natural environment, creating a pleasant nook for the woman and tigers to rest in.

THE FINAL TOUCHES

Last but not least, I add the final touches and details to the illustration. At this point, it's very easy to go overboard with lots and lots of tiny details – after you've finished, take a second look and see what you can remove without losing the work's charm. I opt to add a few thick pieces of grass to add to the textured, cute aesthetic I'm going for. Remember, art is subjective and there is no right or wrong way to create a piece. The most important thing is to make conscious decisions about your design and learn how to improve for next time.

LET THERE BE LIGHT?

I considered adding some highlights to imply lighting, but ultimately I decided they overcomplicated the concept. I also think there's a charm in keeping lighting out of this piece – the look remains less grounded in reality without a light source, which I prefer.

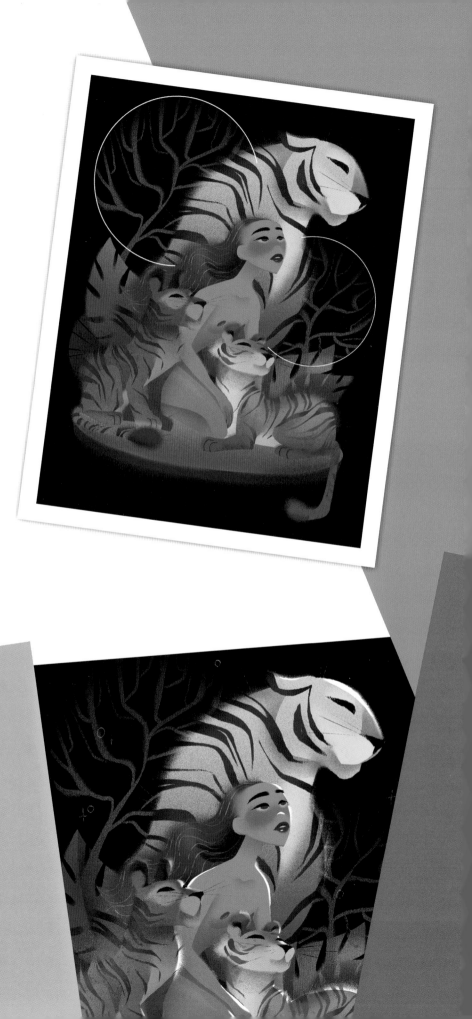

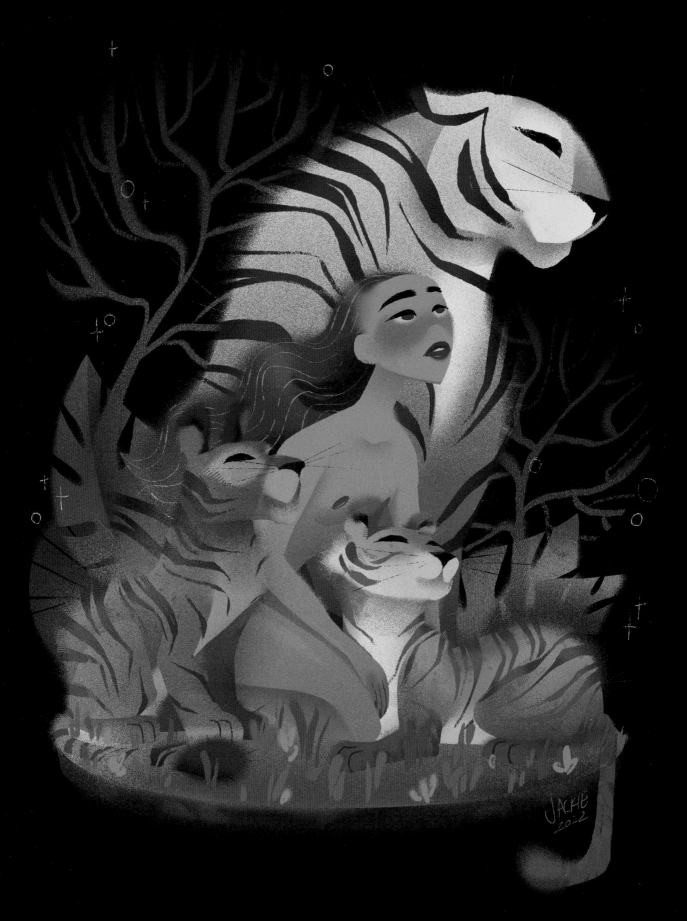

Final image © Jackie Droujko

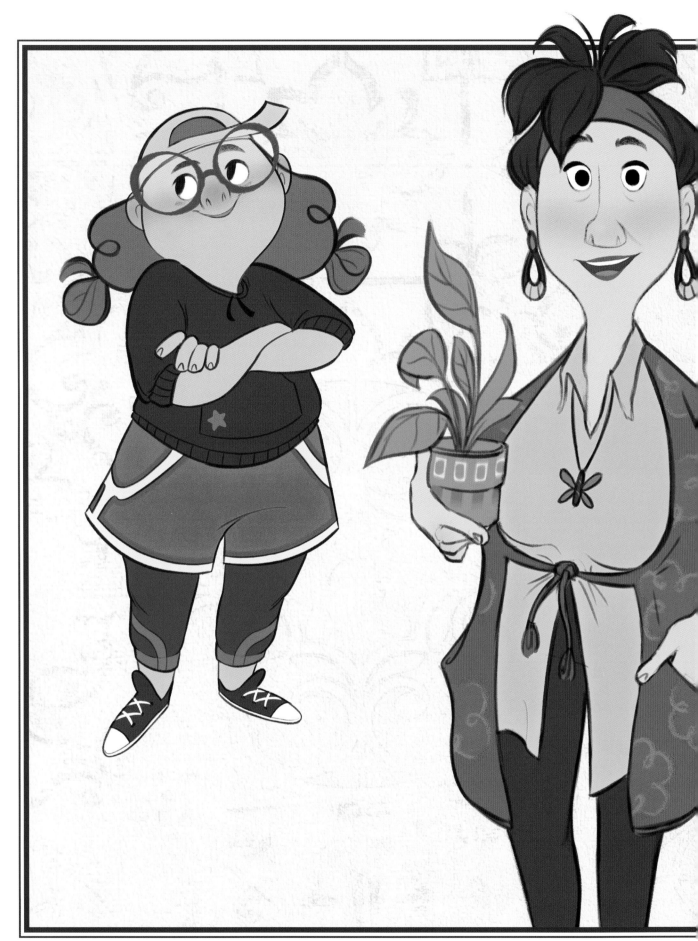

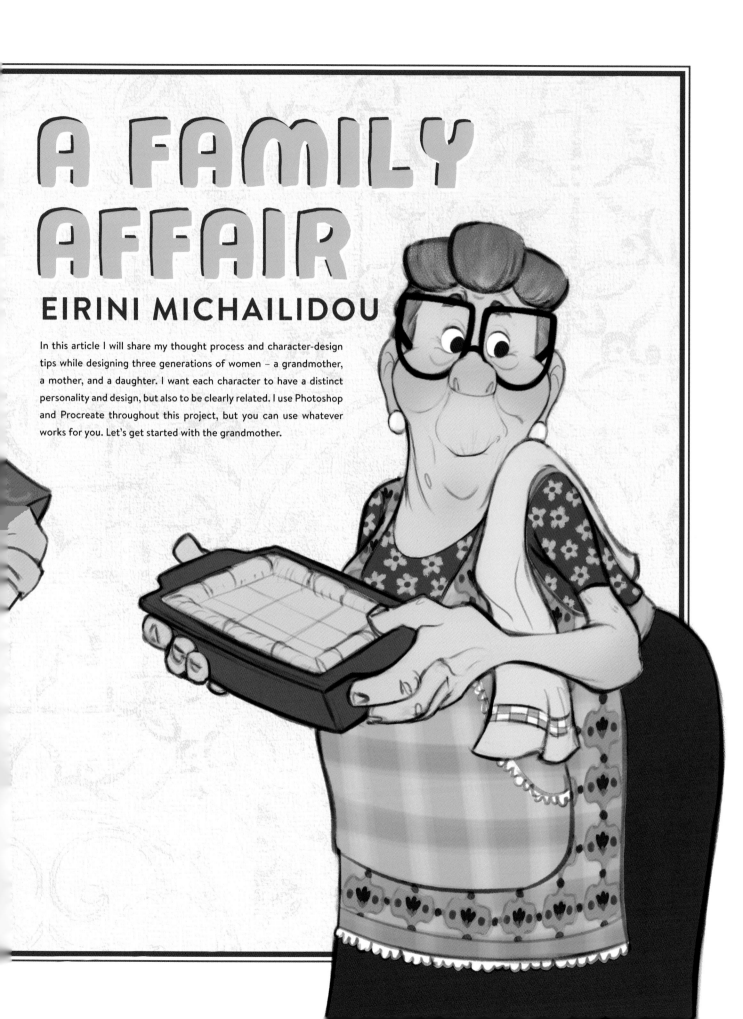

A FAMILY AFFAIR

EIRINI MICHAILIDOU

In this article I will share my thought process and character-design tips while designing three generations of women – a grandmother, a mother, and a daughter. I want each character to have a distinct personality and design, but also to be clearly related. I use Photoshop and Procreate throughout this project, but you can use whatever works for you. Let's get started with the grandmother.

THE GRANDMOTHER

THE BRIEF

First things first, we need a brief. This doesn't have to be a huge amount of writing – a couple of words or doodles will do the trick. With this base established, you can then start searching for more inspiration and references. My own Greek Yaya is a great inspiration during this process, especially for the clothing and how everything revolves around food.

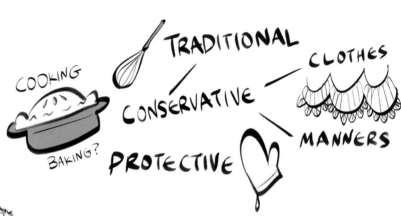

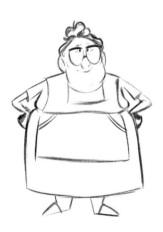
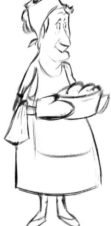
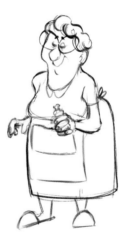
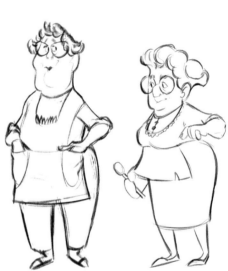

FIRST THOUGHTS

Start sketching some ideas. There's no need to have clean or pretty designs at this point, just put your thoughts on paper. For my traditional grandmother I'm exploring ideas that communicate her passion for cooking, while trying to keep square-like forms to show the stiffness of the character.

A GAME OF BALANCE

Don't fall in love with your first sketch. Take the one you see potential in and explore some more. Push the shapes, try different heights or body types and play around with items of clothes and different patterns.

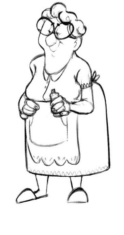
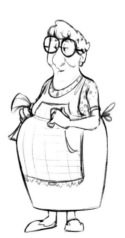
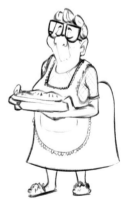

GET TO KNOW HER

I now have a clear idea of what I'm going for, but I need to see the character moving in order to better understand her, and to decide on the final design. Think of your character's traits, hobbies, passions, and how they would carry themselves. Feel free to tweak the face or proportions to nail the personality.

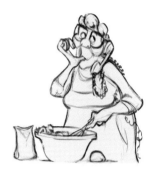

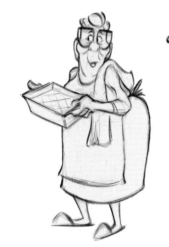

SAY IT WITH COLOR

It's always good to try a few options and see what works best with your brief. The grandmother I'm designing is traditional and conservative, so I settle on a more muted color palette, floral patterns, and lace.

GRAVITY

When designing an elderly character, remember the impact gravity has on the human body. This can be especially visibile on the eyelids, jaw, and cheeks. Similarly, noses and ears start drooping as we age, so they can appear much larger.

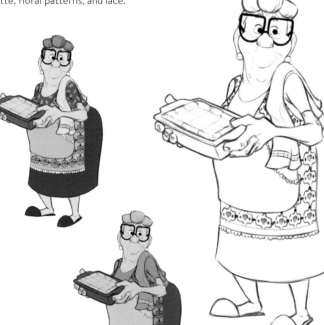

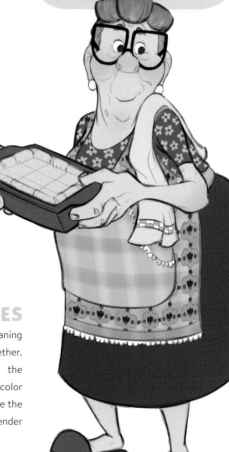

FINISHING TOUCHES

For the final step it's all about cleaning up and putting everything together. I clean the linework and define all the patterns on the clothes with the color palette I selected. If you want to take the design even further, you could render them with light and shadows.

THE MOTHER

WHO IS SHE?

Before you start designing the second character of your story, you will need a totally new brief. The goal is for all the characters to feel real, each one with their own traits and interests. So this time, when designing the mother of the family, I am focusing on her carefree personality and her positive vibes. Each element of this character and the next should be compared to the grandmother design throughout to make sure the line-up all look interesting and unique, but also related.

LAY OUT YOUR OPTIONS

Let's start with a few options for body shapes. Since you already have one character designed, you can explore the silhouette of the new one next to it. This is an easy trick to help you stay within the same type of stylization, especially when you are trying to create members of the same family. This time I focus on circular shapes to emphasize the character's loving and caring nature.

FACE/OFF

Sometimes, when I'm unsure of who my character is, I focus solely on the face. You can try different facial traits, hairstyles, or expressions – find your character without stressing about the rest of the posture, and then match it to any body shape you want.

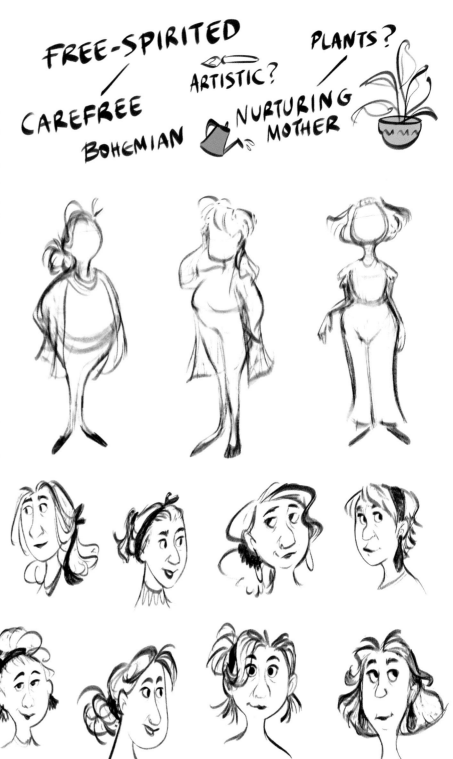

FREE-SPIRITED

CAREFREE

BOHEMIAN

ARTISTIC?

NURTURING MOTHER

PLANTS?

MIXING & MATCHING

Once you have selected a couple of faces, you can mix them with your body silhouettes and start to dress them up. Always go back to the brief and your references to get inspiration for clothing. My initial goal was to make her more bohemian and free-spirited, so I'm exploring loose-fitting outfits that can visually communicate that.

A SPLASH OF COLOR

Laying out different color options can make it easier to choose how to proceed. I know I want earthy and warm tones to create a contrast with the pale and cool colors of the grandmother. But even if you have a clear idea of the palette you want, you'll get different results depending on which color is dominant. Remember, don't be afraid to experiment.

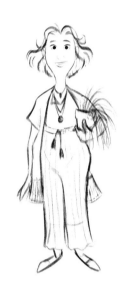
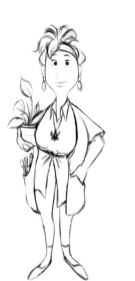
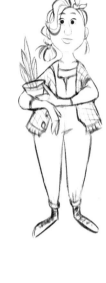

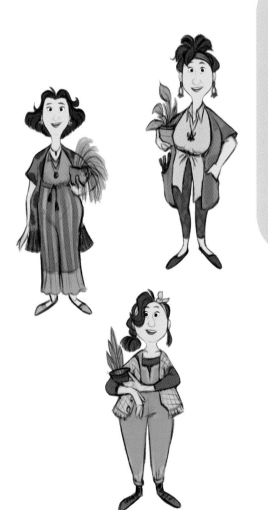

FAMILY TIES

When designing members of the same family, you need to make sure they look alike enough. To achieve this, a good trick is to pick an element that can be repeated throughout the whole family's design. In my case, it was the shape of the nose. Be careful when using this trick – too many similar elements can make your characters look too alike, as if they are the same person in different stages of their life.

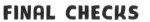

FINAL CHECKS

It's time to place your characters side by side and make sure they both stand out as unique personalities. During this step, I realize that the mother needs more saturation overall, to ensure she stands out as different from the grandmother.

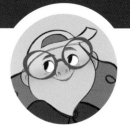

THE DAUGHTER

LET'S BEGIN AGAIN

By now, you can probably guess where we're going to start – we need a plan. Figuring out who your character is at the very beginning would be great, but don't get discouraged if you don't have a clear idea yet. All you need is a few words to get you started. Let the doodling begin.

"FEEL FREE TO ADD DIFFERENT TRAITS AS YOU EXPLORE"

ANYTHING GOES

An energetic young girl who's passionate about sports could be, for example, a confident feminine girl or a shy tomboy. She could excel at sports or just be trying to fit in. There are endless choices to make when defining your character – feel free to add different traits as you explore the dynamics each option creates.

MASH UP

There are times that you are going to like more than one sketch during exploration, making it hard to eliminate anything. If this happens, you can take all the available options and mash them up to create a new version for each. Pick and choose the elements you prefer and add new ones as you go. Feel free to try this process multiple times until you find your perfect character.

ENERGETIC ★ PLAYFUL
YOUNG SMART ATHLETIC

COLOR WITH PURPOSE

Knowing who your character is will help when deciding colors. Personality traits can greatly affect color choices – for example, a confident character might have no problem wearing bold and vibrant colors to stand out from the crowd.

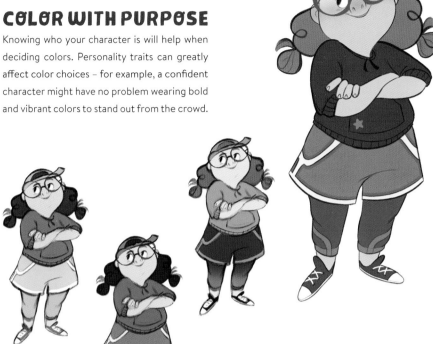

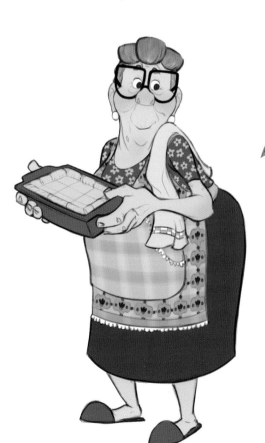

THE ELIXIR OF YOUTH

When designing small children, keep in mind that their facial features are not completely defined yet - this means that parts such as the cheeks and chin can be skipped. Also, you can make the character look youthful by bringing the eyes, nose, and mouth closer together. Use this technique to emphasize the age of your character, or to highlight their naivety among characters of the same age.

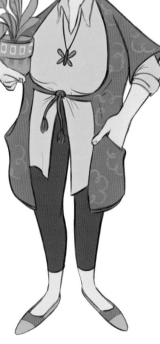

THE GRAND FINALE

With each character completed it's time to bring them all together on the same page. Check their scale alongside one another and make any adjustments if needed. And there we have it – our little family is complete!

MEET THE ARTIST:

EDDY
OKBA

Eddy Okba is a French animator, currently based in Canada, who has worked on some of the biggest films of the past few years. We spoke to Eddy about his route into the industry, and his experiences at various film studios, and asked him for some tips on how to follow in his footsteps.

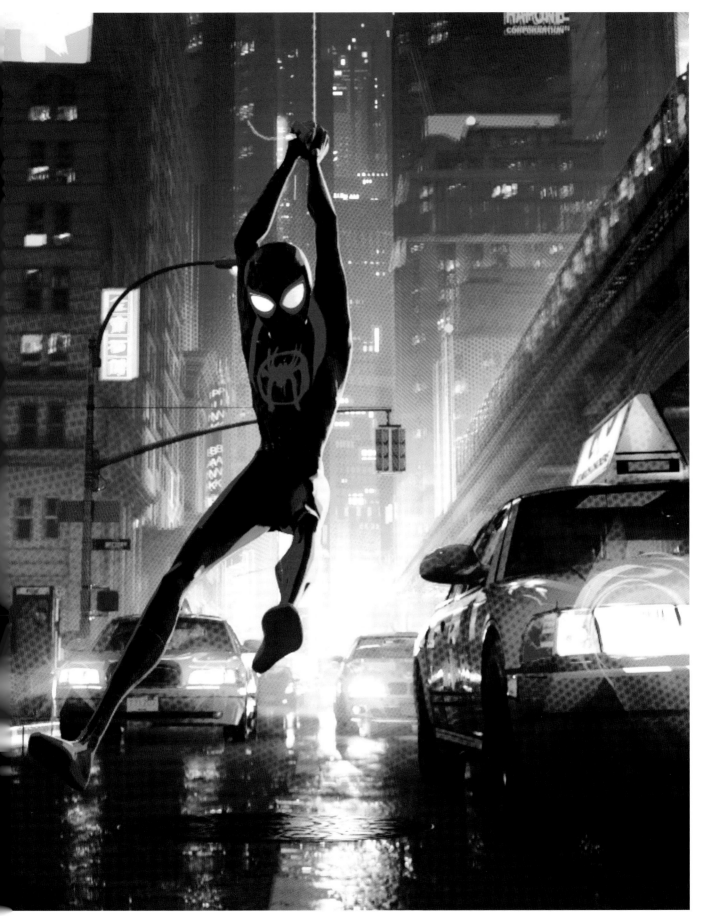

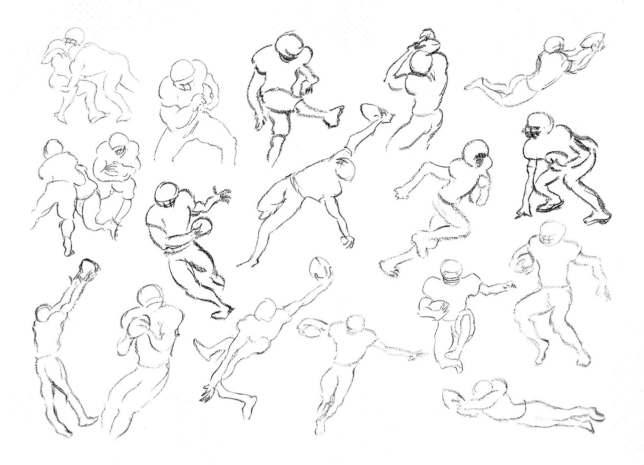

Hi Eddy, thanks for taking the time to speak to CDQ. First off, could you give our readers an overview of your career so far?

Hi, *CDQ*, thanks for having me! I'm originally from Paris, France, and I started my career at Illumination Mac Guff. I spent eight years there, working on *The Lorax*, *Despicable Me 2*, *Minions*, and many other features. I was originally a crowd animator but starting with *Minions* I became a "main character" animator. After completing *Despicable Me 3*, I had the opportunity to work on an animated *Spider-Man* project at Sony, which I couldn't turn down. So, in 2017 I moved to Vancouver in Canada to work on *Spider-Man: Into the Spider-Verse*. It was a great experience and the movie won the Academy Award for Best Animated Picture in 2018. Next, I worked on *The Willoughbys* at BRON Studios for Netflix, and I was Lead Animator at Animal Logic on the upcoming *DC League of Super-Pets*. Most recently I worked on *Lightyear* at Pixar.

You've certainly worked on some huge productions. How did you start working with big animation houses?

I started at Illumination Mac Guff right after my graduation thanks to a healthy dose of luck. In my second year at school I worked with

a professional animator tasked with animating a series of monologues for a cartoon vampire bat. He was working on this alone, I guess with a tight budget, so he hired me as an intern. It was a golden opportunity for me: no real pressure, personal feedback from a professional, and monologues to animate – the perfect exercise for an animator. The following year, he was working at Mac Guff and was unavailable when needed to show a blocking (the very first version of an animation shot). He suggested I could block the shot for him. I went to Mac Guff for a week and stayed for eight years.

Your route into the industry certainly sounds unique. Do you have any general advice for our readers who are looking to land roles at the bigger studios?

To work with big studios you have to excel at a specific skill. I dedicated my career to animation even though, after finishing school, I was interested in visual development, character design, and storyboarding. It doesn't mean you can't work in other areas once you've got your foot in the door, but it's important to target a few disciplines at first. The bigger a project is, the more specialized each artist will be, so you'll need to work hard and be highly skilled in your chosen area to give yourself the best chance of getting a break.

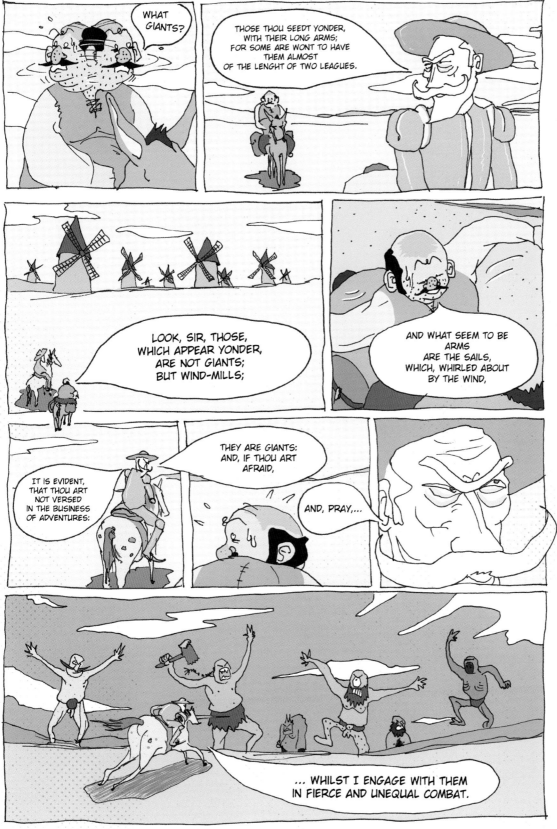

Opposite page:

A gesture drawing is a great exercise for animators and storyboard artists to study movement and shapes

This page: A page from a comic-book adaptation of Cervante's *Don Quixote*

Images © Eddy Okba

Collaboration must be important when working in a big team, such as Pixar. How does your work overlap with the rest of the team?

As an animator, you work on shots (or chunks of shots) included in a sequence. You are in charge of the acting and the performance of the characters based on the plot, the dialogue, and the actors' voices. The storyboard and layout let you know what's happening in the shot and the staging required, and the director tells you what he envisions in his mind. You also need to reference the surrounding shots – you don't want your character to be over-excited when they were completely chilled out in the previous shot. So, you talk to your colleagues, with your lead, and make sure everything works well together. Sometimes, you may have an idea that would involve a camera change or an audio tweak, in which case you would talk to the editing department and layout crew to make that happen. If the shot includes special effects or cloth simulation, then those departments would be involved as well. It's a very collaborative job. Everybody is working together to make the shot the best it can be, sharing techniques, software skills, and feedback. It's an exciting environment to be in.

Have you found that working at Pixar, Illumination Mac Guff, and other studios were similar experiences, or is the culture different at each?

The culture is a little different everywhere, but everyone shares the same passion. Pixar and Illumination Mac Guff are dedicated animation studios – they're producing and making their own movies, so they have a long-term vision for their company. They're great places for artists to stay and grow. Hybrid companies (that work on animation and VFX) often have a higher turnover of staff, depending on what shows and clients they are working with. There are so many factors that can affect an artist's experience, including budget, schedule, expectations, and the complexity of the project. Each project you work on will always end up feeling personal and will carry memories of that particular stage of your career.

These pages: Pages from the manga
Wrestling Paradise by Eddy Okba

Images © Eddy Okba

Let's talk about *Spider-Man: Into the Spider-Verse*. It has such an amazing, original, and coherent look and feel. Was there anything that was special about working on this project that allowed such a bold look to take form?

During the interview for the role, the Animation Supervisor was really excited about the concept, and told me that it would be challenging, but very special. I was really intrigued and convinced by his enthusiasm to join. And he was right – it was not an easy film to make. Animated movies are usually filmed at 24 frames per second (FPS) but for Spider-Verse, animators were told to drop one frame out of two, creating a less smooth look, almost like stop-motion animation. This technique gave the film a comic-book style – we have less fluid motion, but much stronger poses on screen. Another difference from traditional animation was the lack of motion blur. Usually, motion blur is added to give the impression of movement, like the effect created by a camera in real-life. To add to the comic-book effect, we used drawing lines and multiple limbs to simulate movement instead.

We studied a lot of Japanese anime and reproduced some of their methods, such as placing a character animated at 12 FPS on a 24 FPS background for a sharper look. On the character's faces, we created lines to draw wrinkles and push expressions, like a comic-book artist would do. And it wasn't just the animation department innovating – the FX, lighting, and compositing departments created so many cool graphical elements, like onomatopoeia text, CMYK layers for depth of field, screentone textures, and much more. Every department pushed the style to its full potential. It definitely wasn't easy to believe it would work at first. For example, we worried the audience would find seeing fewer frames than usual jarring. Thankfully, it all came together, and the result is stunning.

This page: Thumbnails from *Spider-Man: Into the Spider-Verse*, and the finished shot. Animators can plan their shot using thumbnails or video references

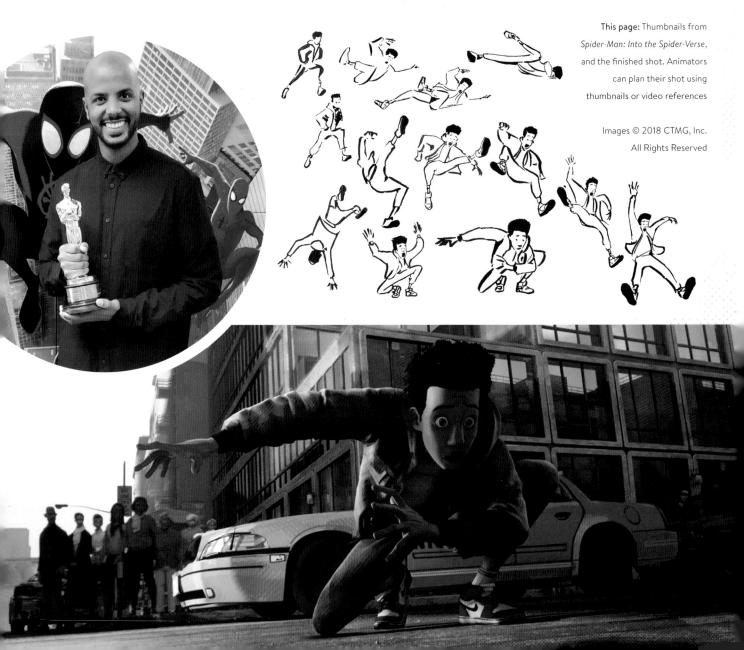

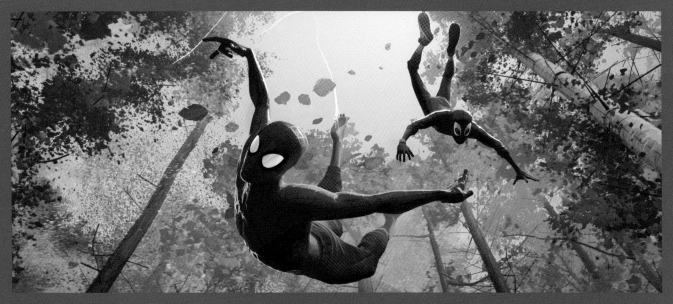

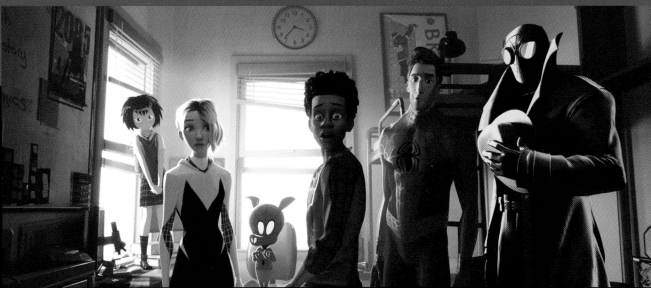

When working on big existing properties, as you did with *Spider-Verse* and *Lightyear*, how much freedom are you given to express yourself? Are there strict rules about what can and can't be done with the characters?

While I don't think there are necessarily rules, we're limiting ourselves in a way – I've known these characters since I was a kid, long before working in the industry, so when they act differently than the audience is used to, it feels weird for me too. For *Spider-Verse*, it was

something new, even if Miles Morales existed in comic books and cartoons. The limits to which we're working come from the writing and design of the characters. At the beginning of the film, Miles is still a kid, so that's how he behaves. When he discovers his powers, he's surprised and a bit clumsy, enjoying the sensation of new movement. The movie is about the character finding himself and his own style, so that gave the artists freedom to express themselves.

At the end of the day, we're crafting what the directors have in mind and want to show the

audience. It's a pretty subjective task, there's no right or wrong way to interpret a character. As an animator, I have the freedom to propose and suggest an acting performance, sometimes several for the same shot, which we'll then talk about, and try to choose what's best for the film. It all comes back to how collaborative the whole process is – each department and artist adds their own layer based on the director's vision.

This page: Stills from *Spider-Man: Into the Spider-Verse*

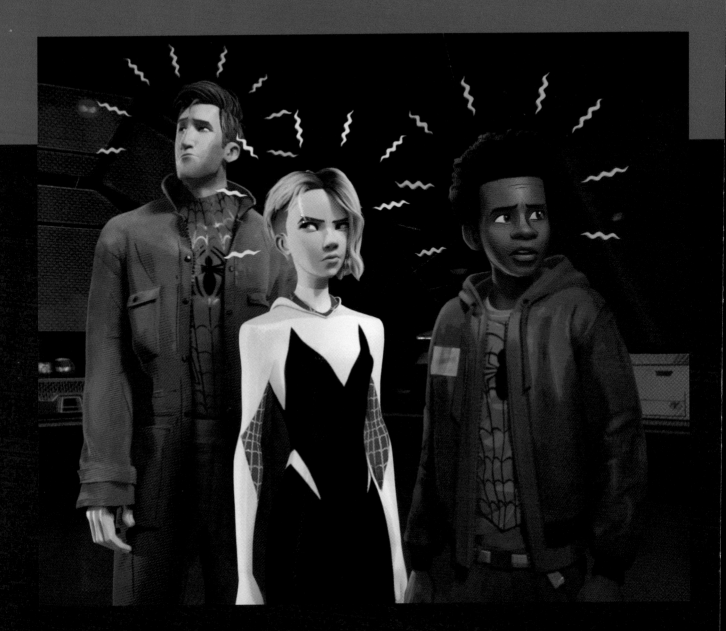

You mention on your website you are looking to move into story development. Is there a lot of overlap between doing that and animation or character design?

I've always been fascinated by comic-books and manga – I actually attended art school to be a comic-book author before discovering animation. Storyboarding is very similar to creating comic books – you're telling a story with drawings and each panel has to communicate something to the audience. In animation, we're focused on a character's

performance and how they act, which in turn needs to keep the audience interested in the narrative. So, there is an intrinsic link between animation and storytelling. When you start to work on an animation or design, you're telling yourself a story as to why the character looks and acts the way they do. Having an understanding of storytelling will help with design and animation, for sure, and vice versa. Many of us that work in animation chose this career because we wanted to be storytellers. I'd like to storyboard a feature in the future and to write my own comic book.

What's the most challenging project you've worked on, and what did you learn from that experience?

Spider-Man: Into the Spider-Verse was a very tough project. The look, the animation style, the workflow, the tools that the team created – everything was totally different from what we were used to. There was a lot of freedom which was exciting, but also uncertainty, at times. It was like a brand new beautiful world to explore and we didn't know if we were heading in the right direction.

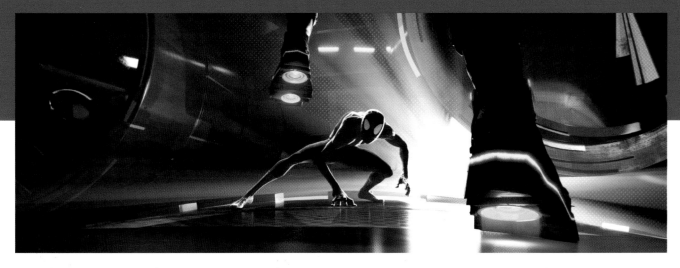

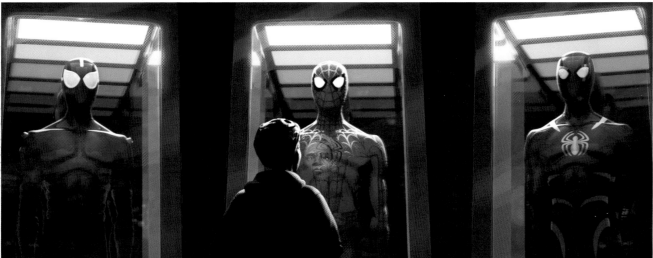

You learn many great rules and principles at school and with experience, but with this movie it was like starting fresh and bending all those rules. It was gratifying to see that people responded to it so well.

Minions and *Despicable Me 3* were also challenging in a way, because therewas a lot of expectation around those films. It's really hard to make something new with familiar characters – you don't want to do something totally different or "betray" their existing designs, but you also want to create something new enough to keep the audience interested.

If you could give our readers one piece of advice for good character design, what would it be?

For me, a good design should tell a story to the audience. Whether we're talking about a character, an environment, a simple prop or an animation, they should evoke a background story – the audience will see it and get what you're going for, even if only on a subconscious level. Also, it's difficult, but you should always try to avoid stereotypes, generic traits, or clichés – they can be helpful to give the audience a quick idea of personality, but they should be used specific to a character, not a gender, ethnicity, or culture.

Weaving story through every aspect of your design will make your characters credible to the audience, even if you're not looking for realism. For animation, there are universal aspects of body language you can use, but try to tweak them to be specific for a character, a logical fit for their personality and body shape. Props are also a really powerful tool. Something as simple as a table can say a lot about a place in time, personality, culture, and much more.

These pages: Stills from *Spider-Man: Into the Spider-Verse*

A MOTION MASTERCLASS

JOAKIM RIEDINGER

Our whole universe is in constant motion – flowers grow, trees sway, people walk, and everything is always evolving. Movement is at the center of our lives, but how do you express this energy in your work? Let's look at a few principles that will help to translate force into movement in drawings.

DRAW SMALL, QUICK THUMBNAILS FIRST

Drawing small thumbnails allows you to think about the overall design, silhouettes, and action lines, rather than focusing on small details. It's also much faster to generate a lot of ideas when they are done in a few seconds.

STARTING STATIC

To create the illusion of movement and motion in your drawing, you need to avoid symmetrical poses. They tend to stiffen a drawing and seem unnatural – unless, of course, you want to convey that someone is firm and strict, like this police officer.

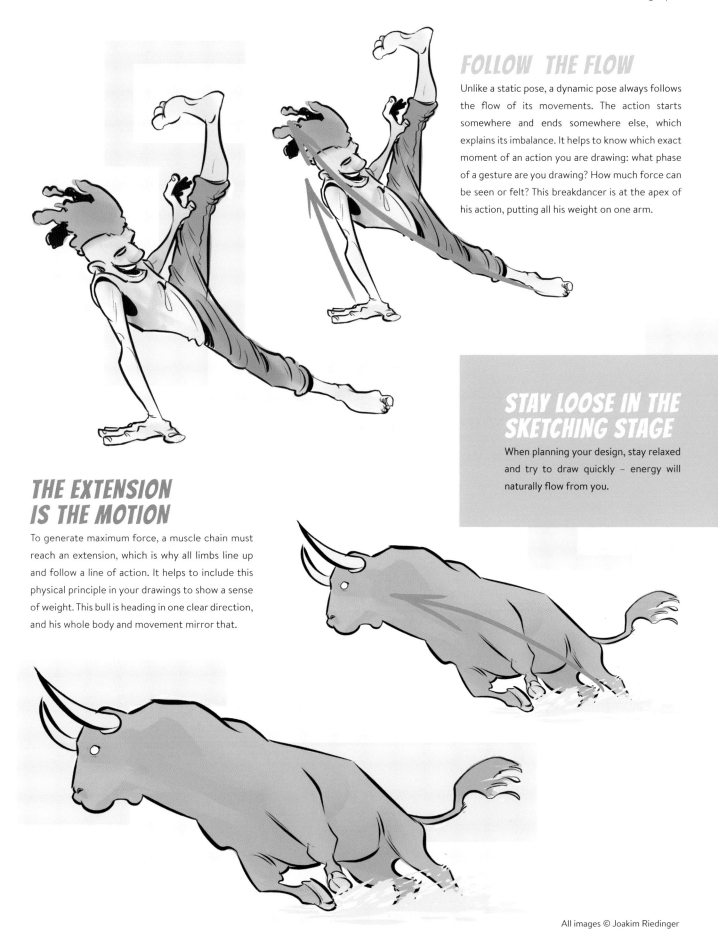

FOLLOW THE FLOW

Unlike a static pose, a dynamic pose always follows the flow of its movements. The action starts somewhere and ends somewhere else, which explains its imbalance. It helps to know which exact moment of an action you are drawing: what phase of a gesture are you drawing? How much force can be seen or felt? This breakdancer is at the apex of his action, putting all his weight on one arm.

STAY LOOSE IN THE SKETCHING STAGE

When planning your design, stay relaxed and try to draw quickly – energy will naturally flow from you.

THE EXTENSION IS THE MOTION

To generate maximum force, a muscle chain must reach an extension, which is why all limbs line up and follow a line of action. It helps to include this physical principle in your drawings to show a sense of weight. This bull is heading in one clear direction, and his whole body and movement mirror that.

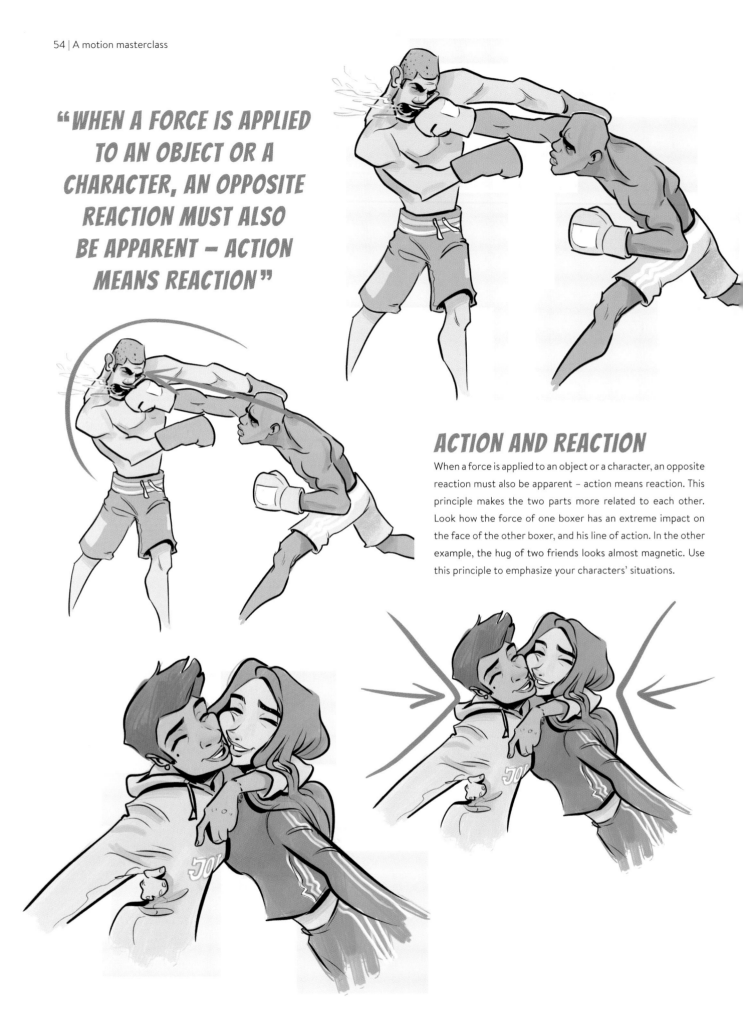

"**WHEN A FORCE IS APPLIED TO AN OBJECT OR A CHARACTER, AN OPPOSITE REACTION MUST ALSO BE APPARENT – ACTION MEANS REACTION**"

ACTION AND REACTION

When a force is applied to an object or a character, an opposite reaction must also be apparent – action means reaction. This principle makes the two parts more related to each other. Look how the force of one boxer has an extreme impact on the face of the other boxer, and his line of action. In the other example, the hug of two friends looks almost magnetic. Use this principle to emphasize your characters' situations.

LAYER AND INCREASE ACTION LINES

To make a gesture more textured and interesting, try to introduce a multitude of patterns that align with a consistent overall direction. Look at the contours of this dancer's pose – not only does her dress show curvy movement, her body does, too. This multiplicity of curvy lines will enhance the sense of rhythm and fluidity in the action lines, and adds a certain grace and elegance to your character.

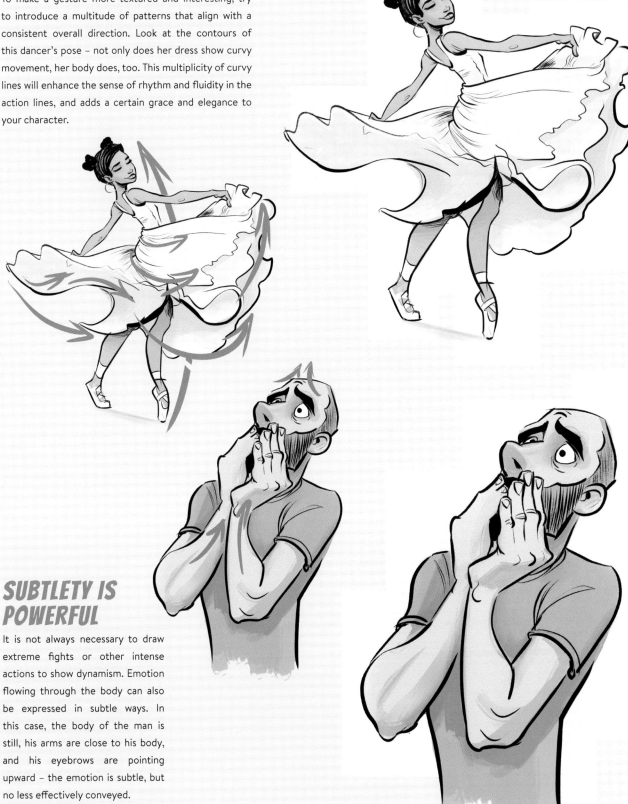

SUBTLETY IS POWERFUL

It is not always necessary to draw extreme fights or other intense actions to show dynamism. Emotion flowing through the body can also be expressed in subtle ways. In this case, the body of the man is still, his arms are close to his body, and his eyebrows are pointing upward – the emotion is subtle, but no less effectively conveyed.

DEVELOPING A STORY BEAT

DANIEL TAL

In this tutorial I will talk about my process for developing a story beat from start to finish, including how I develop the characters, their personalities, and the world they inhabit. I will show my process for how I think about characters in the context of a greater story, and all the elements you need to consider to create a believable story beat. This will all be done in Adobe Photoshop, but you can follow this tutorial in any program, or even traditionally on paper.

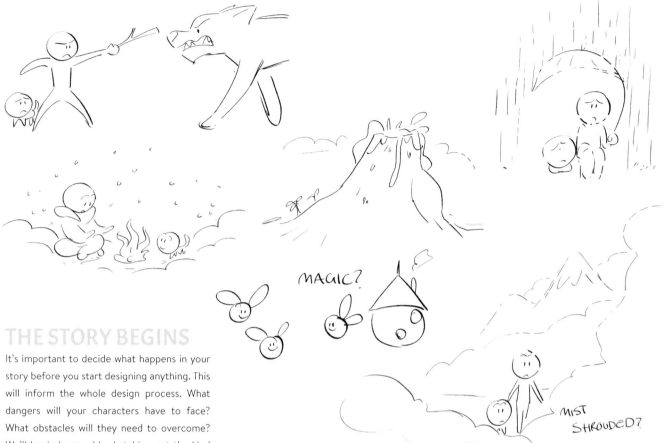

THE STORY BEGINS

It's important to decide what happens in your story before you start designing anything. This will inform the whole design process. What dangers will your characters have to face? What obstacles will they need to overcome? We'll begin by roughly sketching out the kind of things your characters will encounter – the environment, weather, and threats. You need to know if they will be trekking through snow, avoiding the rain, or even having to face down monsters or local wildlife. For my story, I'm trying to think about a wide variety of possibilities, including magical elements.

EXPLORING IDEAS

Creating thumbnails for the story beat is probably the most important step in creating an intriguing world and interesting story – this step will inform the narrative the most, in terms of character and world-building. You should be thinking outside the box to create fun scenarios for your character. Draw very loosely and keep the characters very minimalist. Ideally, you want to produce lots of thumbnails to really hone in on the best possible story and composition for the story beat. I've decided to push scale and character personalities for these particular beats.

PICK YOUR FAVORITE

Once you have a variety of story thumbnails sketched out, it's time to select which beat you would like to design your whole story from. With that decision made, you can see what design elements you need to figure out. The story beat I've chosen leans heavily into a fantasy setting: fairies floating around our heroes as they drift through a swamp. From here you can see the size relationships you need to consider, how the environment plays a role, and any auxiliary characters you may need to design. In this case, I need to design the fairies that we'll encounter. You can also see that the animal companion character needs to be large enough for the child to ride on.

"THE STORY BEAT I'VE CHOSEN LEANS HEAVILY INTO A FANTASY SETTING"

Opposite page (top): Work out the parameters of the story you're trying to tell

Opposite page (bottom): Keep your thumbnails loose – and make lots!

This page: Work out what elements you'll need to create

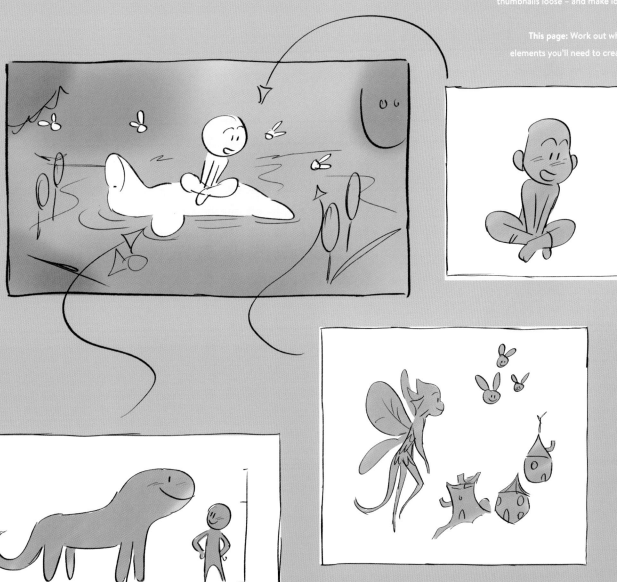

SHAPING THE STORY

To start designing the character, play around with broad shapes. Take a basic square, circle, and triangle, and start applying them to various aspects of your design. Experiment by pushing the shapes in different ways, seeing which formation best represents your character's personality. If you want a stronger character, you may want to stick to boxier shapes and lean more toward squares and rectangles. For this design, since I'm portraying a sleepy child, I'm going for softer and more circular shapes to accentuate those character traits.

"EXPERIMENT BY PUSHING THE SHAPES IN DIFFERENT WAYS, SEEING WHICH FORMATION BEST REPRESENTS YOUR CHARACTER'S PERSONALITY"

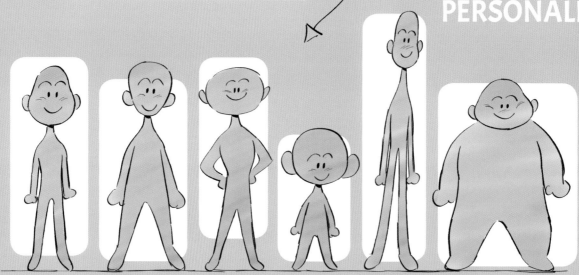

SQUASH AND STRETCH

Don't be too precious with the character you made – really treat their face like a ball, pushing and pulling it to create more fun and appealing poses and expressions. Keeping your design too stiff can stifle and ruin an otherwise great design.

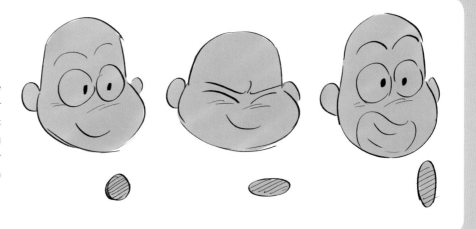

MAKING AN IMPRESSION

To create a unique and appealing design, take your character and push the shapes and features that really accentuate the personality you're going for. Sometimes, you can take this too far and create a caricature – a character that seems to only have one single personality trait. Typically, for a main protagonist, this is something you want to try and avoid.

Since my character is sleepy, I bring her eyelids down to create half eyelids, making her face feel very bottom heavy – almost like a droopy pillow. Have fun with this step and see what adjustments make your character stand out the most.

A GOOD HAIR DAY

The right hair can say a lot about a character and how they are perceived. Messy hair can show a disorderly, lazy character, while neat hair can make your character seem suave and well put together – perhaps even snobby. You'll want to explore a bunch of options here. Even the difference of a few stray hairs sticking out can change the perception of a character. I'm trying everything from messy updos to long, braided hair just to see what fits best. Since she's a sleepy child, I'm going to go with the super messy hair. Also, exploring an island wouldn't really give her time to focus on her hair.

Opposite page: Broad shape designs are a great place to start

This page (top): Amp up the personality, but avoid caricatures

This page (bottom): Every element of a hairstyle can make the difference to a design

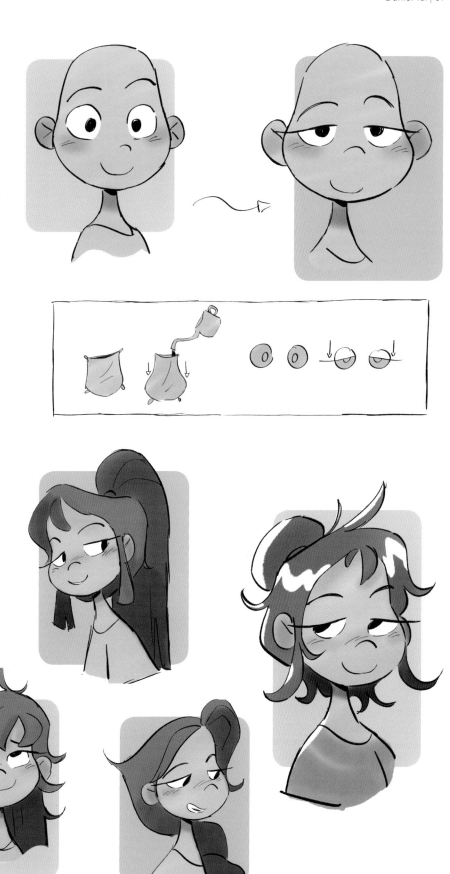

DRESSING FOR THE OCCASION

Like hair, clothes can say a lot about your character. The outfit speaks not only to your character's individual personality, but also to the situation they find themselves in. A winter coat might be necessary if the island is especially cold or snowy, or a hoodie can symbolize a more modern time period. These are all elements you need to think about when picking the right outfit for your character. I'm going for an oversized shirt with shorts to show that she was practically swept out of bed and thrust on this adventure.

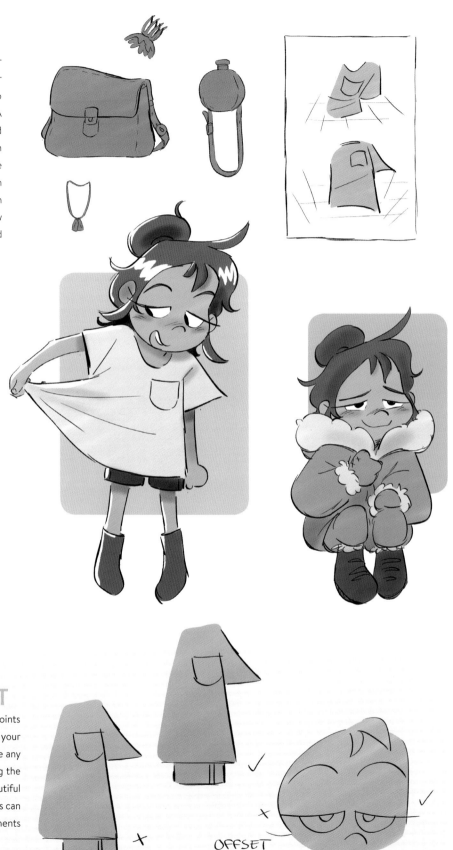

OFF ON A TANGENT

Tangents can create uncomfortable points for the audience's eyes. Always check your design when you're finished to make sure any unintentional tangents are fixed – having the audience get distracted from your beautiful design is the last thing you want. Tangents can also apply to story beats and all the elements within them.

OFFSET

FINALIZING YOUR CHARACTER

Once all the individual elements are in place, you can start the fun part: adding little details that really make your character stand out. Maybe add a satchel that holds a map and other items? Perhaps your character always has their laces untied? Adding in these little quirks can make your character feel alive and as though they exist in a fully formed world. This will push your design to the next level.

GETTING TO KNOW YOU

With the design of our character fleshed out, it's time to figure out their personality. Put yourself in the mind of your character and think about how they sound and act – are they sassy, excitable, shy? Put your design to the test and see just how far you can stretch their face to create fun and appealing expressions. It's also important to try out different angles to show every side of the face - don't just stick to the three-quarters front view.

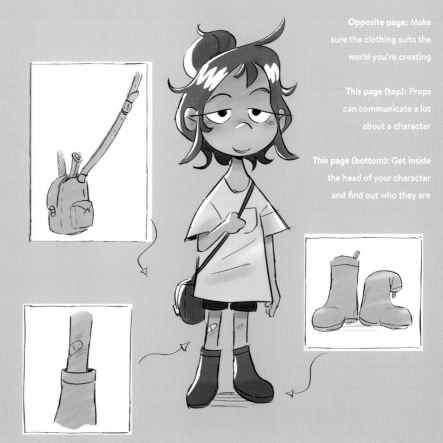

Opposite page: Make sure the clothing suits the world you're creating

This page (top): Props can communicate a lot about a character

This page (bottom): Get inside the head of your character and find out who they are

"PUT YOURSELF IN THE MIND OF YOUR CHARACTER AND THINK ABOUT HOW THEY SOUND AND ACT"

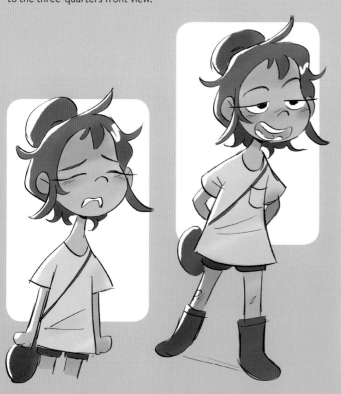

PICKING A PERFECT PARTNER

With our main character finished, it's time to create the perfect companion to accompany them on their adventures. Here you want to think about everything from the type of animal (or even mythical creature) to the scale difference between your main character and their companion. It helps to research a variety of animals, as your choice will affect the development of the rest of the story and interactions between characters. I want my main character to ride on top of their animal friend, so I try out several larger animals and check their comparative scale.

FINALIZING THE NOBLE COMPANION

Now that you've seen your character and their potential companions side by side, it's time to pick one to carry forward and really hone in on their design. Since I want my character to be able to ride their animal friend through water, I'm going with a big lizard. When designing animals, it's important to keep in mind that any pattern on their body should be varied. Avoid repetitive and static designs as these can leave the design looking boring and dull. Any detail, like spots, spikes, hair, or even teeth, should vary in size and shape.

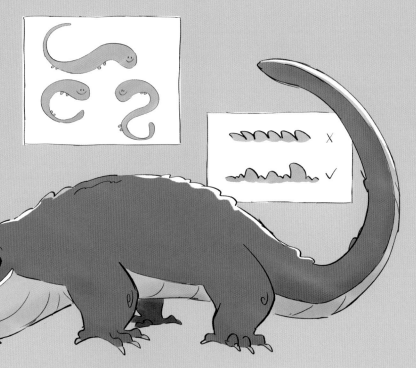

"EXPLORE THE RELATIONSHIP BETWEEN THE CHARACTERS AND HOW THEY INTERACT WITH ONE ANOTHER"

RELATIONSHIP ADVICE

Next, explore the relationship between the characters and how they interact with one another. This is key when working out your story beat. Just as you did when thinking about the personality of the characters, start by asking yourself questions. How much will they physically touch? How do they feel about each other? Do they get along or are they at odds? Work out the answers to these questions and use the information to create fun poses of the characters together.

Opposite page (top): As well as creating a strong look, consider the practical aspects of creature design

Opposite page (bottom): Details need to be unique to remain interesting

This page: Explore the interactions between character and companion

THE WORLD COMES ALIVE

Designing the setting is a big task in itself – the world our characters reside in is almost like a whole separate character. Make sure you really do your research and examine the exact type of environment you want to portray. Study real-life equivalents, taking the individual elements you find and pushing them to fit your imaginary world. I'm creating a magical bayou, placing elements from my research into a similar realistic environment, and then sprinkling aspects of magic throughout.

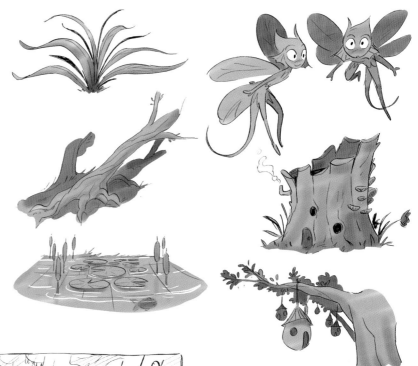

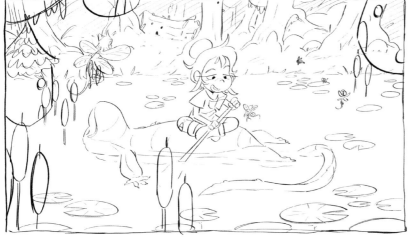

FITTING THE PIECES TOGETHER

With all the individual pieces designed, it's now time to combine them to create the original story beat you are working toward. Start with the line work, really focusing on getting the right composition for the story. Don't worry too much about making sure everything is perfect, as story beats are for communicating how the narrative and characters will work. Next, you should create the base tonal layer – I typically work in grayscale and take three or four varying tones to create a foreground, middleground, and background. This will give you a very good base to work from as you finish up the story beat.

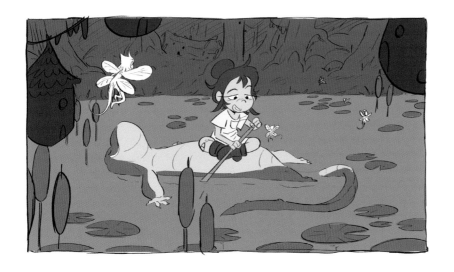

This page (top): Even magical settings benefit from an underlying realistic look

This page (bottom): Pull all your elements together to create a coherent story beat

Opposite page: Finishing touches can take a story beat from good to great.

OTHER IDEAS

Here are some of the designs I went through before settling on the final look for my main character. I felt her face was too squashed in some of these sketches and wasn't malleable enough. I ultimately went with the design that I felt was more fun.

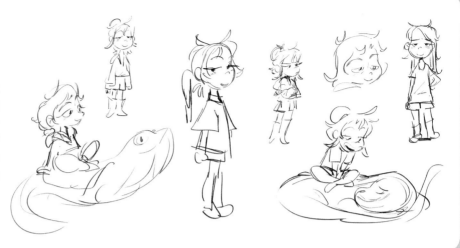

FINISHING FLOURISHES

Now that everything is in place and the tones are laid out, we reach the final part of the process, which also happens to be my favorite – it's time to add the lighting, details, and highlights that really make everything pop. Play around with the mood and time of day to really showcase the story being told in your drawing. Don't be afraid to experiment on other layers to find out what works. Be careful to keep the focus on the characters, letting them shine, and avoiding too much visual noise around them. And there you have it – a fully formed story beat. Now you can use the characters, and perhaps your other thumbnails, to start to put together a whole world of stories.

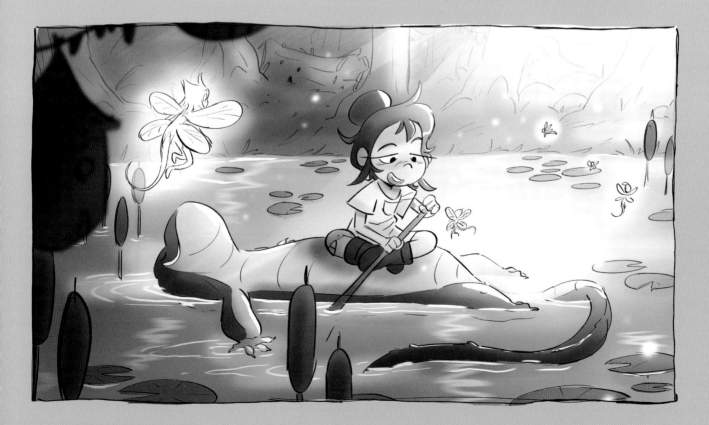

Final image © Daniel Tal

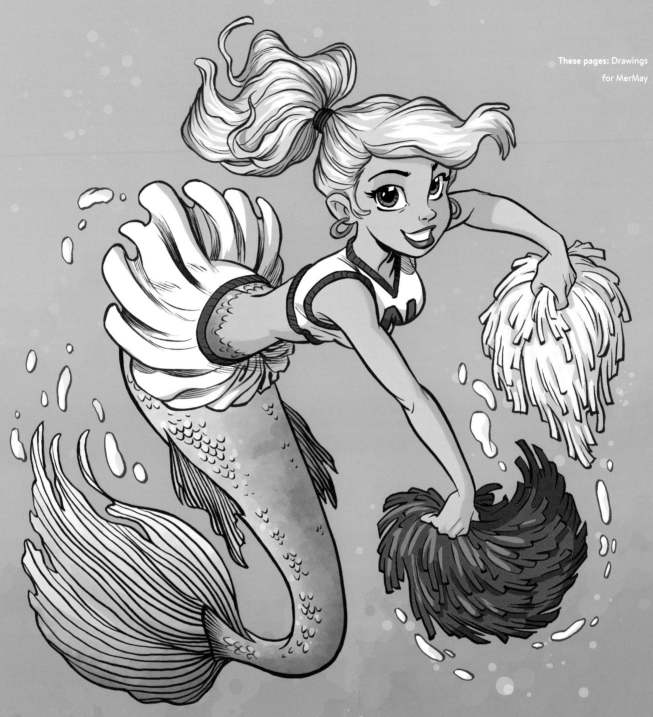

MEET THE ARTIST
TOM BANCROFT

Tom Bancroft is a name many of you will be already familiar with – in a career spanning more than 30 years, he has worked on iconic characters at Disney and beyond, created the incredibly popular MerMay event, and even started his own studio. We caught up with Tom to find out how he got started in the industry, what makes a great character design, and much, much more.

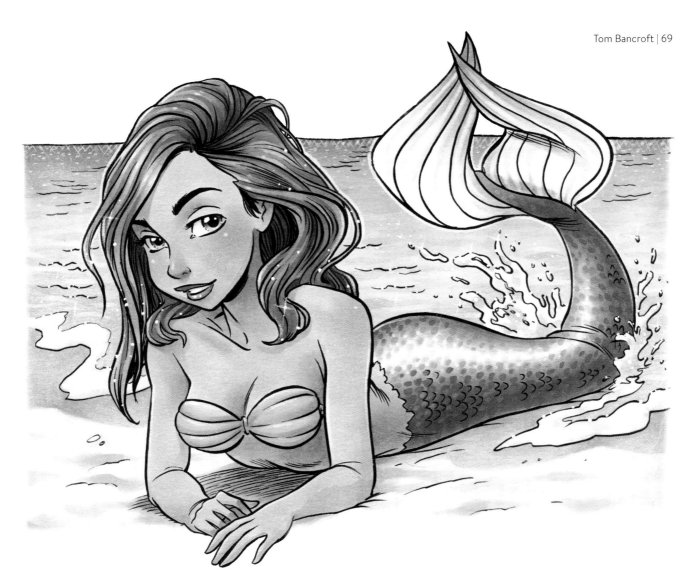

"I'M TOM BANCROFT, NOT TONY – I HAVE AN IDENTICAL TWIN BROTHER AND WE'VE BOTH BEEN IN THE INDUSTRY FOR OVER 30 YEARS."

Thank you so much for taking the time to talk to CDQ. Many of our readers will know who you are already, but to maintain the CDQ tradition please introduce yourself and tell the readers about your career to date.

I'm Tom Bancroft, not Tony – I have an identical twin brother and we've both been in the industry for over 30 years. I'm the one that lives in Nashville, Tennessee. I created Mushu, the dragon in *Mulan*, and animated Young Simba, Pocahontas, Roger Rabbit, and others at Disney. I created and directed the *VeggieTales* spin-off *Larryboy*, and worked on *Superbook* for CBN.

I divide my career into four stages so far: first, "the glory days," working in 2D animation at Disney for twelve years. Then came "the desert years," working on *VeggieTales*, owning my own company (Funnypages Productions) and freelancing on various projects for another twelve years. Next, "the steady pay check years," starting the animation degree program at Lipscomb University, where I worked for eight years. And now, "the last big shot years," in which I've been CEO of Pencilish Animation Studios for the past year and half. That doesn't add up to 30 years, so I'm a little off somewhere, but you get the idea.

I don't think there's a single "bucket list" job I haven't done – from children's book illustrations, animating and storyboarding for feature films, TV series, and commercials, to designing characters for video games, working on comic books, starting internet memes, podcasting, and so much more – I'm old!

For the vast majority of our readers, being associated with iconic animation projects like those you worked on at Disney is "the dream." How did you get your first role there and how would you advise those itching to get comparable jobs at top studios around the world?

The short answer is that it will be a different route for everyone. Of course, you can simply visit a company's website, find a job posting, and submit your portfolio to them, but there are other routes in these days – it's possible to be "discovered" by an art director browsing your Instagram account. It's rare, but it does happen.

As for my experience – I was a student at CalArts when Disney visited the campus to look at student's portfolios for internships. My brother and I both got accepted. This was 1989 and Disney was making *The Little Mermaid* at the time. For those that want to pursue their dream, you need to work hard every day at your craft, especially drawing.

What do you think is the vital component of character design?

A great character design has strong design principles at its heart that fulfill the needs of the story and the personality of the character. Each character is different, so finding the "vital component" that makes a design great is the challenge. After all these years, I know one thing – it's never straightforward.

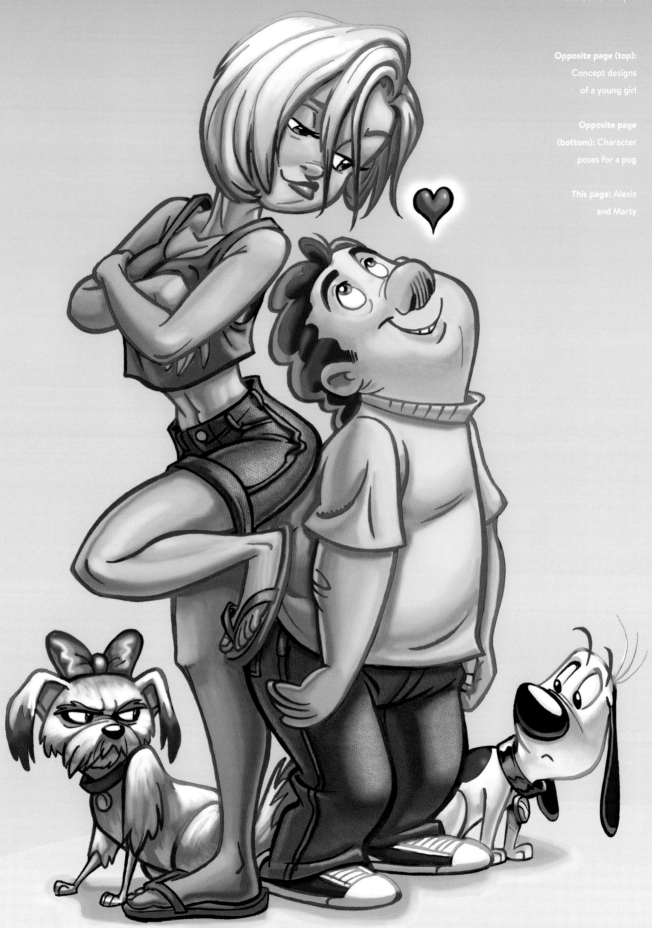

Opposite page (top):
Concept designs
of a young girl

Opposite page
(bottom): Character
poses for a pug

This page: Alexis
and Marty

How do you go about building a character that will work on the screen? It must be incredible to see them come to life.

It can be a hard task to figure out if you're nailing a character's personality in your drawings or animation. I think of creating a character as a four-part process, of which the design is the first and perhaps smallest section. Second, posing and expressions are a huge part of making a design come to life and giving it personality. Third is the performance that comes to life when the character is animated. And finally, the character's voice – a good voice actor can add another huge layer of inspiration and insight into who a character is. I've been blessed that I've been able to work on characters at every stage of this process and see them truly come to life, something not all character designers will have the opportunity to do.

We have to talk a bit about MerMay. What was the motivation for starting it and did you ever think it would become such an enormous success?

I had no idea – especially because I created it by accident. In 2015, I had a moderate following on Instagram and Facebook, and posted a drawing of two teen mermaids sunning themselves on some rocks while looking at their "shellphones" (get it?), as teens do. The drawing went semi-viral and I discovered that other people were drawing mermaids, but rarely with any individualism, or personality. It was clear there were a lot of mermaid fans out there (largely because of Ariel) so I asked my followers to join me in drawing mermaids for a month. It just so happened that May was approaching, and so MerMay was born, a drawing challenge to inspire artists to draw every day. It took off very quickly – it's been going for six years now and has amassed hundreds of thousands of followers, with over 26 million views on TikTok alone.

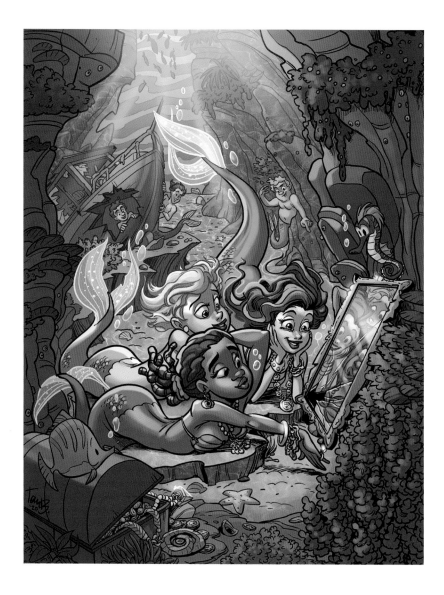

How important and beneficial do you think it is for the vast artist community online to embrace monthly challenges like this?

I think monthly drawing challenges can be hugely important for an artist for three reasons: first, it encourages practice – drawing every day is the best way to grow as an artist, and choosing a couple of months of the year where you devote yourself to not missing a day pays off. Second, "getting out there" will always attract more followers. I hear from artists every year that MerMay increased their follower count on social media, and that, in turn, they also discovered more artists to follow themselves. Finally, I always create a project during MerMay – one year I created a mermaid-focused web comic, one year it was a children's book I wrote and illustrated about a mermaid, and another year my twin brother and I created a full animated short about a mermaid and a seal. I like to try and find ways to turn these projects into business opportunities or products whenever possible.

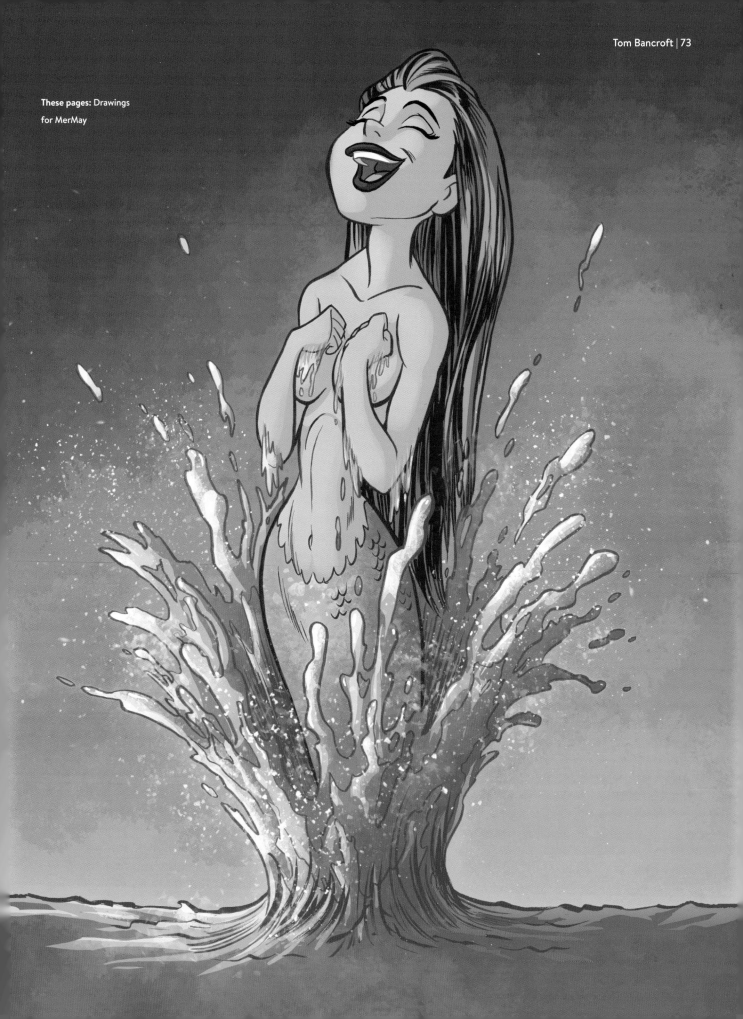

These pages: Drawings for MerMay

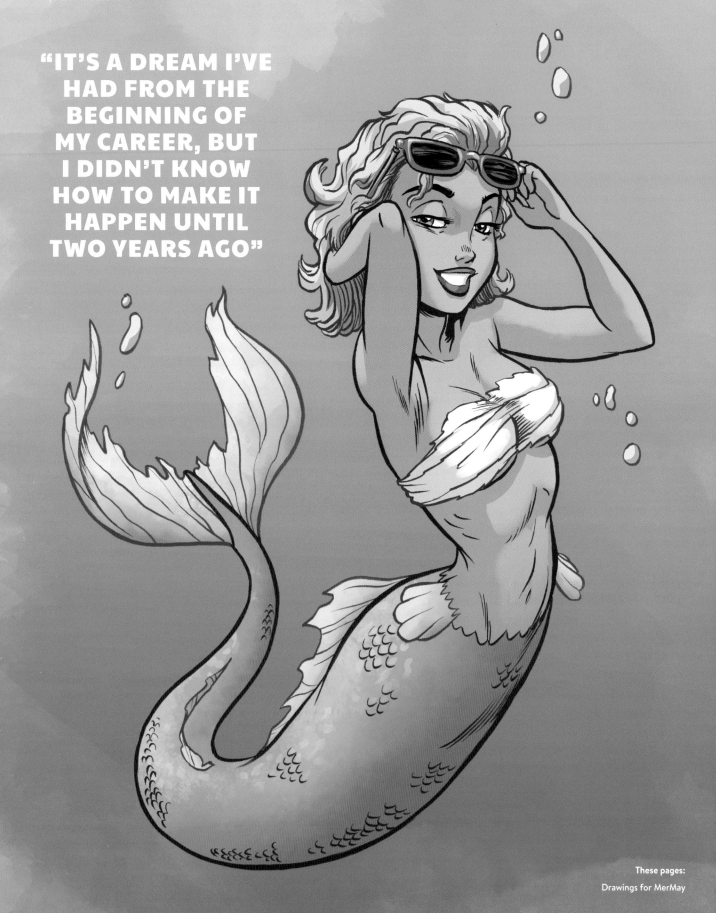

"IT'S A DREAM I'VE HAD FROM THE BEGINNING OF MY CAREER, BUT I DIDN'T KNOW HOW TO MAKE IT HAPPEN UNTIL TWO YEARS AGO"

These pages:
Drawings for MerMay

We noticed on Instagram that you recently opened Pencilish Studios. Can you tell the readers a little about the studio, why you wanted to launch it, and what the future holds?

Thank you for the follow and for bringing up Pencilish! It's a dream I've had from the beginning of my career, but I didn't know how to make it happen until two years ago when I was presented with the perfect storm of tech, crowdfunding, and opportunity. In 2016, new regulation passed in the United States that let the average person invest in start-up companies for as little as $100. It's not a donation – you get actual shares in the company. Before this, only the rich could invest in start-ups and reap the rewards of getting in on the ground floor of exciting new companies. It's not easy to do (and there is a sizeable upfront cost to go through the process) but for me and my partners, this was the chance we'd been waiting for to stop creating characters and stories for the big studios, and start making them for ourselves and our investors. We were able to raise $2.3 million from 4500 investors. We're creating a library of intellectual properties that Pencilish owns, or owns in partnership with other creators. We will be launching on our Pencilish Studios channel on YouTube. We have three animated projects in production now, with more than five others in development. I started the company just after the pandemic began in 2020 and was in development with some of our first shows that summer. It's been a very busy couple of years, but some of the best of my life.

As someone that has seen the development of the industry over 30 years, do you find it easy to identify the IPs that you think will take off and be successful?

I come down on both sides of this question: in some ways, I feel like I'm the most average viewer of all aspects of pop culture, so I'm the perfect person to say, "I think

that will be a hit" and it will, because there's loads of people that like I what I like. On the other hand, anything that's edgy or countercultural, forget it – I won't see it coming, because I'm so mainstream in my tastes.

What do you feel is the consistent element of character design that most people need help with or need to know more about to further develop their skill set?

I am constantly attracted to character designs that are well drawn, "pushed" in their design sensibilities, and are very stylized. Most artists can usually only pull off one or two of these elements in a character design,

myself included – the best of the best can create characters with all three elements. If all three of these criteria are met, then the character will often be described with that vague term we all strive to hear: unique.

Thank you so much for your time Tom. I'm sure we can all think of a million more things we'd like to ask – maybe we can talk again in a couple of years when Pencilish has taken over YouTube and possibly the world?

Ha-ha, how did you know my secret goal? Yes, I'd love to do this again. It's a huge honor to be a part of your magazine – I love *CDQ*.

EXPRESSING EMOTIONS: TEARFUL AND JUBILANT

ALEXIS AUSTIN

There are many ways to illustrate emotion, just as there are many nuances to any given emotion. In this tutorial I'm going to cover how to communicate "tearful" and "jubilant" across three character designs, using a variety of techniques to show off these two contrasting feelings. I use Photoshop and a Wacom Cintiq, but these tips will work just as well in other mediums and styles.

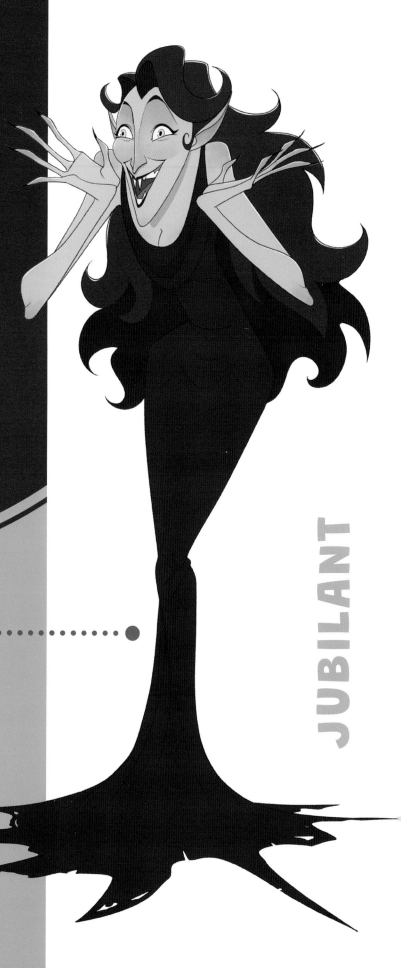

JUBILANT

LINE LOGIC

Show off important physical features. Drawing lines curved upward can help portray positive emotions on the face. This vampire lady is very pointy, with her hairs and ears continuing the upward lines – the jubilant emotion is radiating from all these areas of her design.

TEARFUL

DESIGNING DOWN

On the flipside, drawing lines with a downward curve enhances sadder feelings. In this image, her hair is flatter and her ears droop down. Tears are a quick visual cue, but the emotion is more intense when it flows through the character's entire design and pose.

EMOTE FOR A REASON

Having a reason for a character's emotion is a great way to figure out specific poses and expressions. Even if you are just drawing a lone character against a plain background, come up with a quick story for why they feel a certain way.

PUSH •••••••••••••• FURTHER

This man was initially designed as a generally happy character – we can push him to read as "jubilant" by making his smile wide and his mouth open, with teeth on show. His colors are also warm and bright to match his mood.

REFERENCE, REFERENCE, REFERENCE!

The importance of references cannot be understated. They are incredibly helpful to discover nuances in face movements. Keep a mirror nearby or use your phone camera to make faces at. Observe the people around you.

JUBILANT

TEARFUL

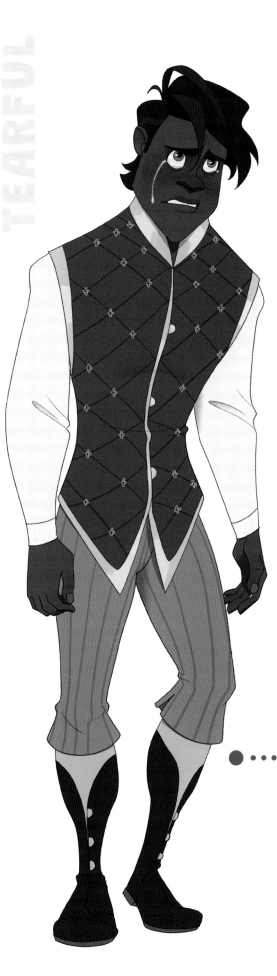

SECONDARY EMOTIONS

Having a secondary emotion in addition to the main emotion can add layers of complexity to your character's appearance. For example, your character is tearful, but what kind of tearful? From grief? Defeat? Happiness? Anger? This extra back-story will allow you to play around further with their design.

COOLING OFF

Taking the warmth from his coloring immediately shifts the mood. Strands of hair now fall across his face and his arms are hung low in a defeated pose. Making a character's cheeks red and splotchy is an effective way to show they've been crying.

JUMP ·······················•
FOR JOY

This bubbly character is showing her excitement through her pose. Her eyes are wide and her mouth is open and curved upward with a very traditional smile line. Her body position is also conveying "jubilant," with her hands gesturing and her leg in mid-air, as if she isn't able to keep still.

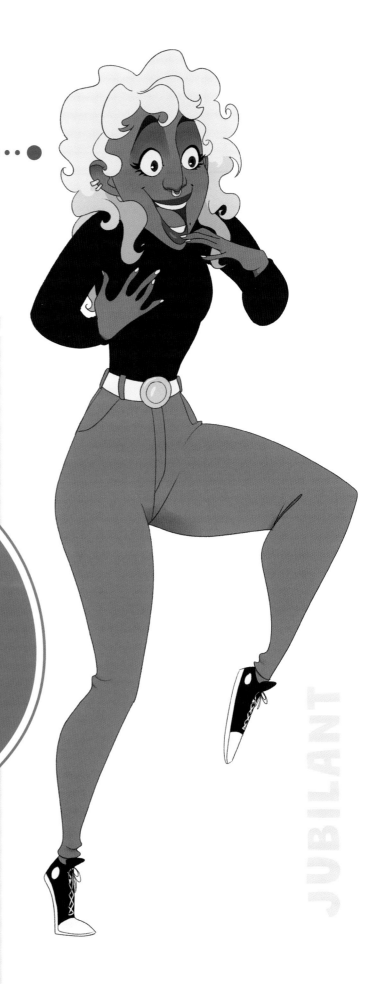

COLORS CREATE MOOD

Pushing the colors to amplify your character's current emotion is a great way to stylize their design. For traditional artists, plan ahead and thumbnail your character with palettes in mind. Digital artists have a few options: you can change individual colors, block out your character in a new color and flip through layer modes, or throw a Color Lookup adjustment layer over them. Remember to play with the opacity on the last two.

JUBILANT

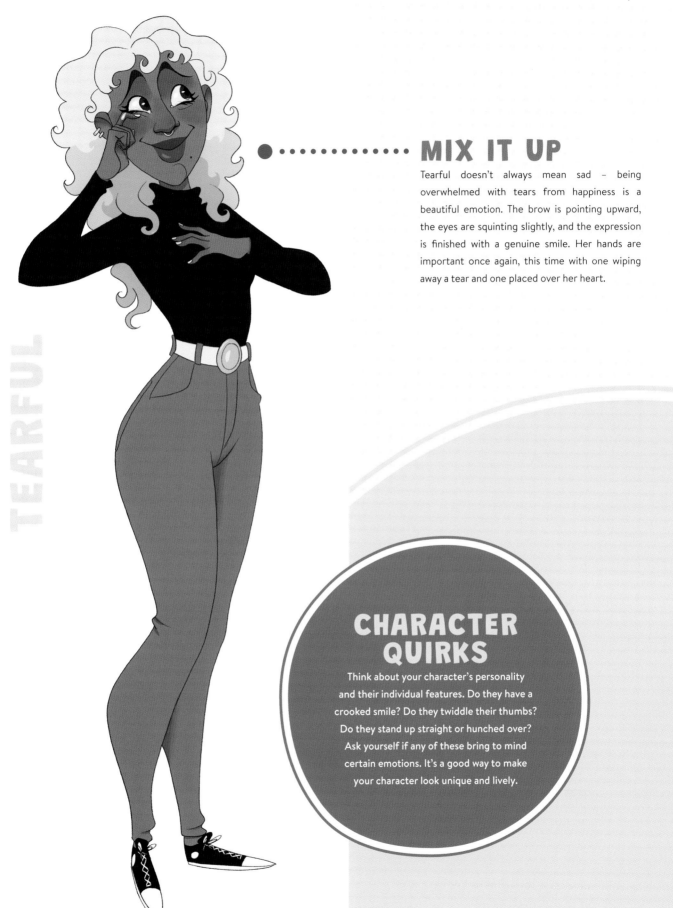

TEARFUL

MIX IT UP

Tearful doesn't always mean sad – being overwhelmed with tears from happiness is a beautiful emotion. The brow is pointing upward, the eyes are squinting slightly, and the expression is finished with a genuine smile. Her hands are important once again, this time with one wiping away a tear and one placed over her heart.

CHARACTER QUIRKS

Think about your character's personality and their individual features. Do they have a crooked smile? Do they twiddle their thumbs? Do they stand up straight or hunched over? Ask yourself if any of these bring to mind certain emotions. It's a good way to make your character look unique and lively.

THE GALLERY

In the gallery we present a fresh selection of art from talented individuals from all across the industry. In this issue we have pieces from three exciting artists: Sylvain Marc, Lisanne Koeteeuw, and Justine Gilbuena.

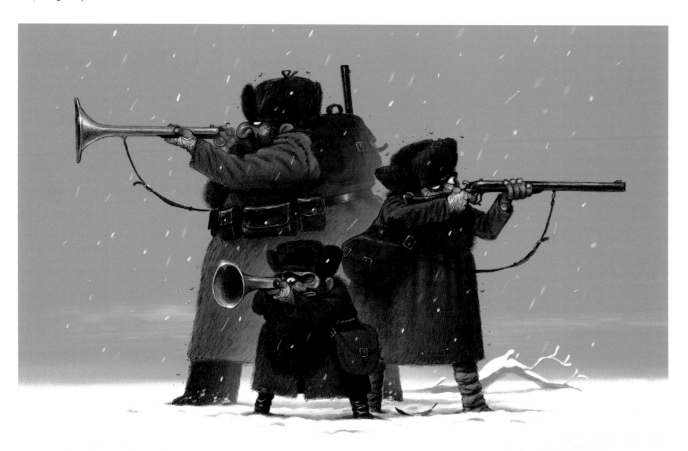

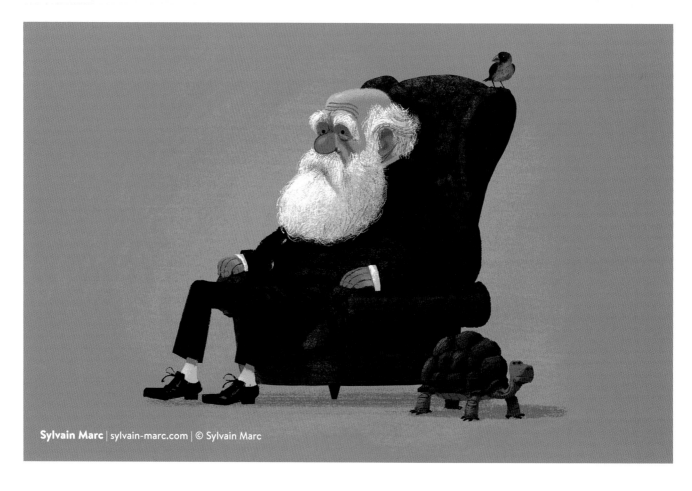

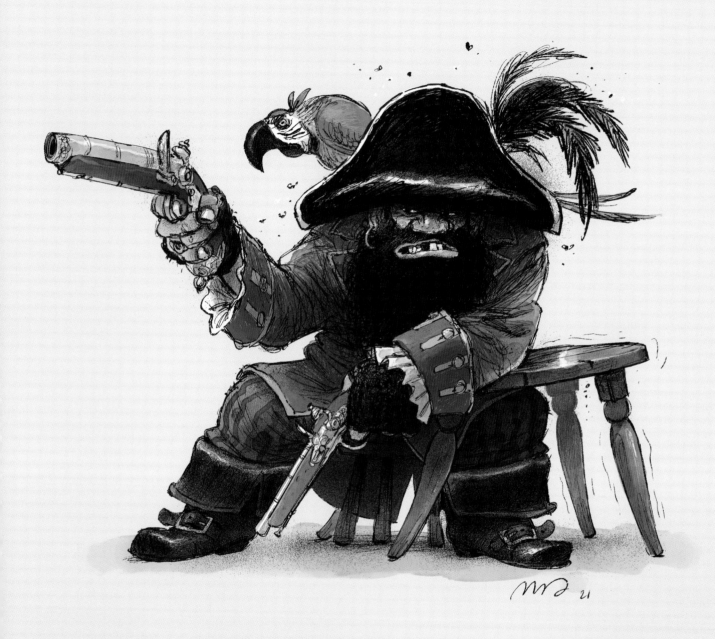

SYLVAIN MARC IS A FRENCH VISUAL DEVELOPMENT
AND STORY ARTIST, ILLUSTRATOR, AND DIRECTOR,
WITH FIFTEEN YEARS' EXPERIENCE IN THE ANIMATION
INDUSTRY. HE HAS WORKED WITH STUDIOS SUCH
AS PIXAR, NETFLIX, LAIKA, AND MORE.

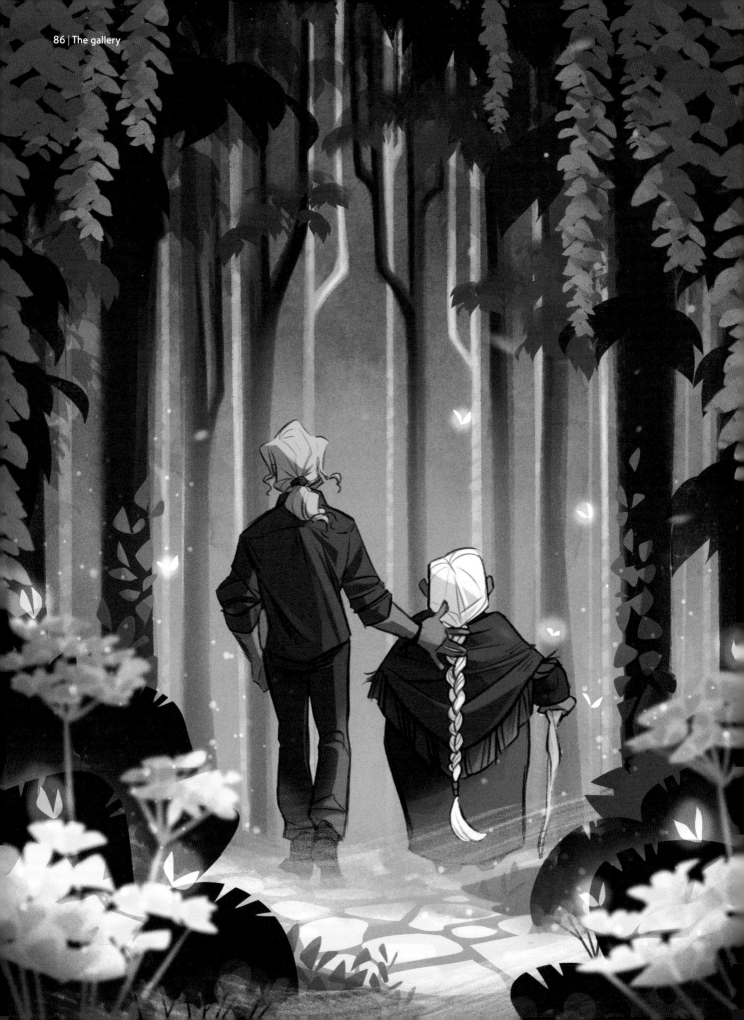

LISANNE IS AN ILLUSTRATOR FROM THE NETHERLANDS WHO LOVES TELLING STORIES, PREFERABLY SCARY ONES. SHE'S CURRENTLY COLLECTING TEA, WHILE WORKING ON HER FIRST SHORT COMIC.

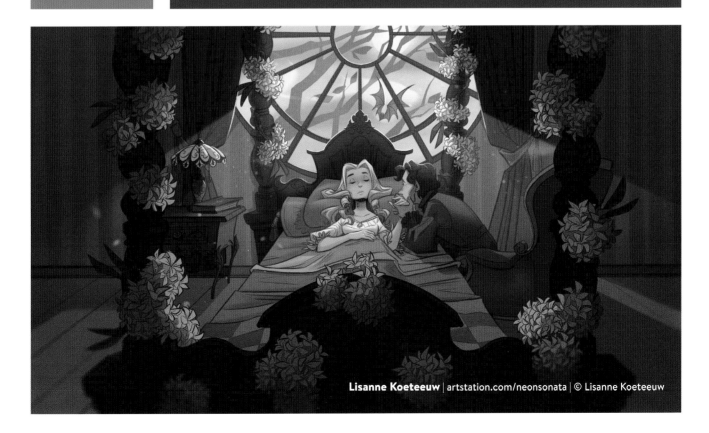

Lisanne Koeteeuw | artstation.com/neonsonata | © Lisanne Koeteeuw

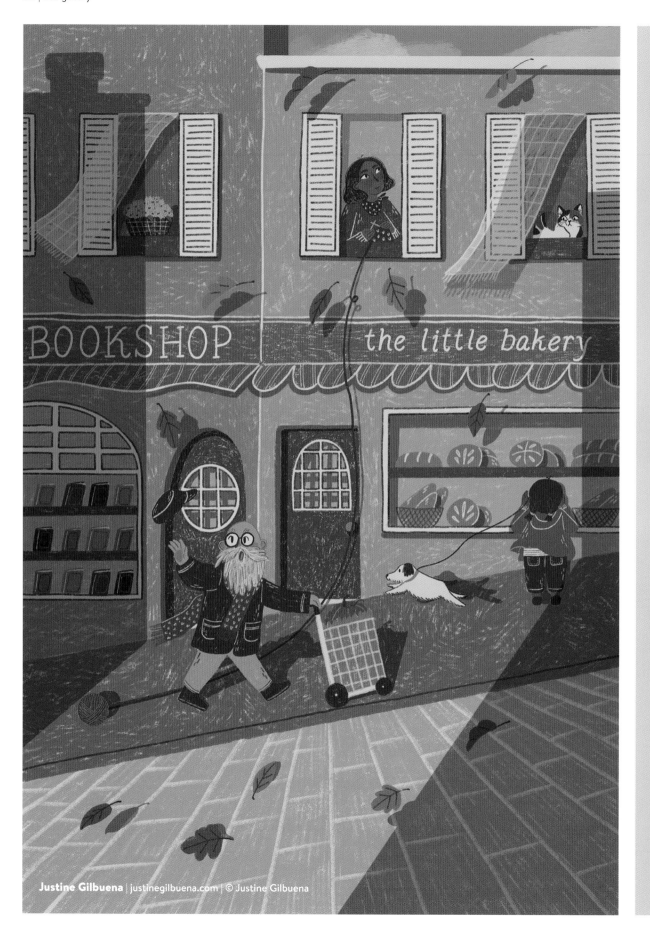

BOOKSHOP

the little bakery

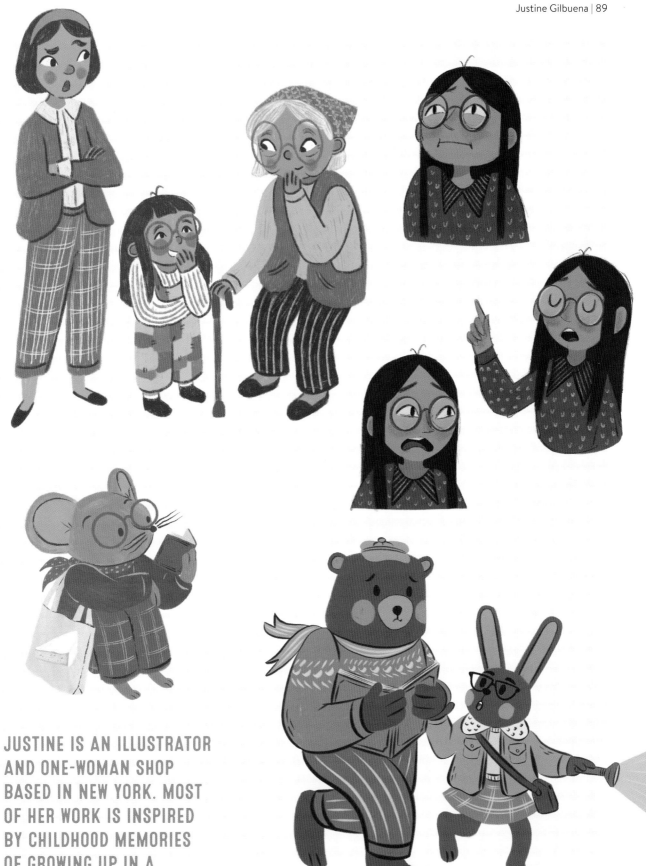

JUSTINE IS AN ILLUSTRATOR AND ONE-WOMAN SHOP BASED IN NEW YORK. MOST OF HER WORK IS INSPIRED BY CHILDHOOD MEMORIES OF GROWING UP IN A FILIPINO HOUSEHOLD.

MECH-ING A SCENE

GREG BALDWIN

Given the choice to design any character, I will always gravitate toward an unwitting mech caught up in an existential crisis, or stumbling into some terrestrial predicament it has absolutely no place being involved in. Something appeals about the theme of an "outcast" that makes me revisit it often. For this design, I imagined the aftermath of a little critter commandeering a battle mech to make its escape. Typically, when designing a character this way, I consider how the final piece will be used. This concept could serve not only as design reference for modelers or animators, but also as an aid to help set the personality and mood for the character in a final production.

DESIGN STUDIES

I like to start with some initial loose design studies. These are often very rough and serve primarily to spark an emotional reaction, positive or negative. It's not uncommon that I will stay at this stage of the process for numerous rounds of review until the "vibe" captures the character's specific personality or abilities. The number one goal is to convey the character's intentions and personality at a single glance. Is the character fast, creepy, imposing? Are they a friend or an enemy? Do they seem hungry? Do they want to eat me? These are all questions I want to try and answer at this stage.

ROUGH POSE AND CONSTRUCTION

Seeing the character in space with volume helps to solve any potential construction issues the initial sketch didn't take into account. Still working as loosely as possible, I block out a pose that epitomizes the character's personality, as well as shows off the entirety of the design. If too many of the important details are obscured by the pose, then additional drawing may be necessary for production. In this case, a three-quarter front pose works well, but most likely a reverse angle will also be needed if the character has unique design elements that can only be seen from the back – like perhaps the newest Fission-Core Long Distance Thruster Pack with Sub-orbital Trajectory Assistance.

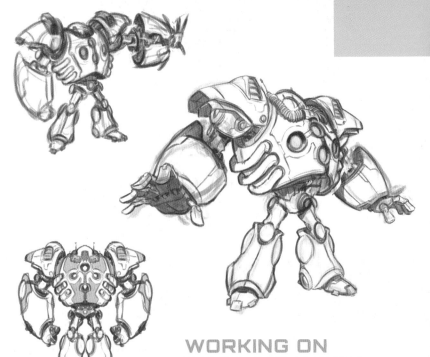

WORKING ON THE LINE WORK

I prefer to work out the specific details of any character using line work first, refining every detail and contour until the flow and functionality all feel believable and accurate. Solving as many design elements as I can, especially on a more complicated character, assures me that anyone else tasked with implementing the design has as much information as possible. I find I get the most satisfaction at this stage – I put on my headphones and just sink into the fun little details knowing the structure and overall design are solid. Now I can focus on bringing this brute to life.

"A SETTING CAN REINFORCE THE VISION OF WHAT THE CHARACTER COULD FEEL LIKE IN THE WORLD IT FINDS ITSELF"

Opposite page (top):
A handful of loose studies can help to hone in on a promising design

Opposite page (middle):
Using your initial sketches, work out how the design will exist in space

Opposite page (bottom):
The line work stage tightens up the design and works out the specific details

This page: Adding a background isn't necessary, but it can help sell the design

BACKGROUND INFORMATION

Obviously, adding a background is not required when designing a character. However, like adding a gentle pose, setting the tone for the character goes a long way to bringing them to life. A setting can reinforce the vision of what the character could feel like in the world it finds itself. Any steps I can take to help the team get to know my creation and its unique situation means that its story will be told more accurately in the end.

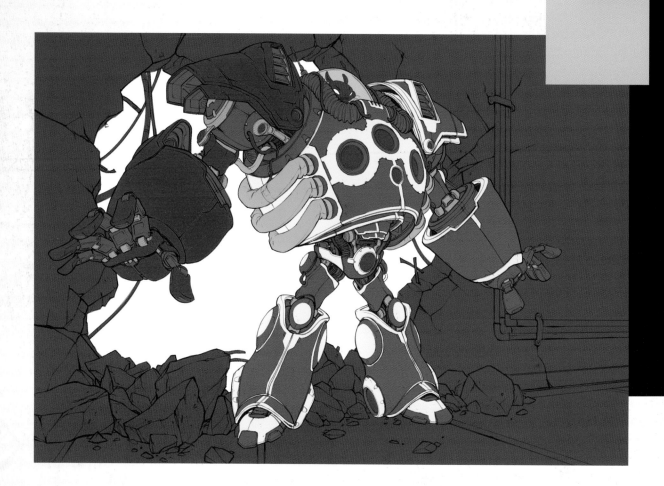

THE BENEFITS OF MASKING

Taking the time to set up masks seems laborious and time consuming, but I find that I more than make up the time spent in future stages of the design. I keep each mask on a separate layer using random distinct colors – this makes loading and reloading crucial selections quick and accurate during the upcoming "Color Palette" and "Rendering" stages. This simple solution allows a lot more freedom to make changes and experiment more easily. Don't forget to name your layers.

FINDING THE COLOR IDENTITY

A huge part of the character's design is their basic color identity. The most popular characters on the planet have immediately recognizable color palettes. This is a major part of designing characters that are intended to be iconic and unforgettable. Using the masks from the previous step, I can quickly try different palettes to try and create an identity that suits who I want the character to be. Do I want them to feel utilitarian, fashionable, alien? Creating various color options can alter the character's story and persona just as much as it makes it memorable.

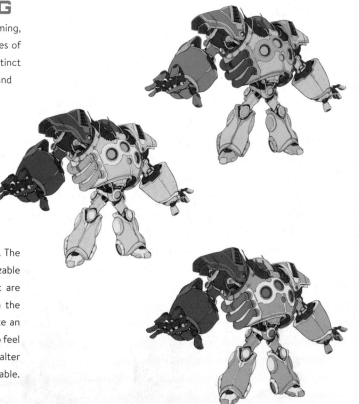

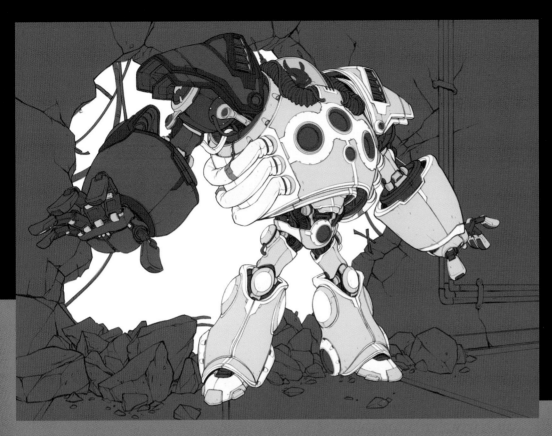

Opposite page (top): Masking out the major elements helps with rendering, as well as color exploration

Opposite page (bottom): Creating base color palette options helps to establish different identity possibilities

This page (top): The final color palette reinforces the character's persona

This page (bottom): Adding elements like decals to the character helps establish the world it inhabits

A COLORFUL NARRATIVE

I decided this mech should have a subtle military-issue look, augmented with a replacement arm – possibly scavenged from another mech that was an arena fighter in its previous life. Juxtaposing the saturated red of the arm against a more subdued green body reinforces the varied histories for a more complex and intriguing backstory. I tie them together with the red lights and uniform mechanical substructures to help create a cohesive whole. Finally, by using a bright teal on the glass dome, I create a strong focus on the pilot to complete the story I'm trying to evoke.

CREATING DECALS AND GRAPHICS

Adding decals and other graphics conveys a sense of the character's past and how previous events have impacted its life up to this point. I designed this decal sheet specifically for this character to reinforce the notion that the mech was built from mismatched parts. The decals for the main mech are reminiscent of a fighter jet, while its red arm has more of a menacing past. I prefer to layout the decals on a single sheet so I can keep the design language consistent and take advantage of fonts and other design tools.

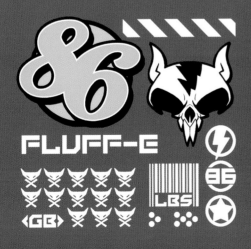

SMART OBJECTS

When applying elements like graphics and decals, one way to keep things adjustable it to utilize Photoshop's Smart Objects. Convert the decal to a Smart Object before any Warp or Transform modifier is applied. This essentially saves a mini file inside the main file. After modifying it and adding adjustments to it, double click on the layer to open the mini file – any changes made within will be updated with all the modifications added to it in the main file after it's saved. Once this is set up, changing decals and graphics out becomes dead simple, and super fun.

DECORATING WITH DECALS

One of the most important aspects of placing graphics on a character is to set the correct scale. I like to think of the intended function of the decals or, in this case, who built the mech. The cockpit size suggests the pilots were fairly small, so the labels need to reflect that. With the help of a Warp tool or a Lattice Modifier, the decals can be distorted to follow the forms of the character which will give them a more realistic appearance.

WEATHERING SURFACES

A character's past often leaves a mark – if this mech was right off the production line, crisper highlights and pristine paint would work well. But this mech has been through a lot and so chipping up the paint, adding dirt into tiny nooks, and dripping oil from its failing hydraulic lines felt more appropriate. Going back to the masks, I can load selections of the painted areas and then use various dirt and scratch brushes to paint in exposed metal.

This page: Applying the decals adds history and a strong sense of scale

Opposite page (top): The amount of weathering and aging emphasizes how old or worn out the character might be

Opposite page (bottom): Shading is the most effective way to show the volume of different forms

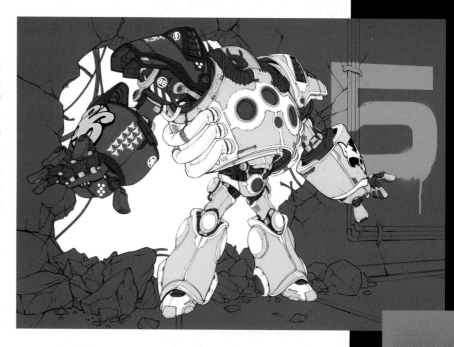

SHADOWS AND LIGHT

Shading the character not only makes the design look more believable, it also indicates the general volume and distance between parts. This step is a bit like doing a math equation, which can be daunting. I tend to start off looking for an easy part, like the shoulder that in this case is a basic sphere, and use it to guide the rest of the light logic on everything else. The two most important parts of shading in my mind are how shadows fall across the form, and how blurred the shadow becomes based on the distance from the source to the cast surface. These two aspects of shadows can indicate so much useful information – plus, it looks pretty wicked.

BASE METALS

Use the masks to create a selection that includes all the areas from which the paint will be chipped and worn away. On a new layer above the paint layers, create a mask from the selection. After filling the layer with a gray, use rust and dirt colors to paint the metal so it looks aged and grimy. Use this layer during the weathering stage and the revealed metal will have lots of interesting detail wherever it's exposed.

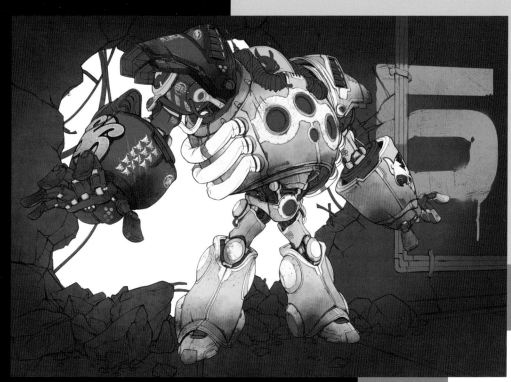

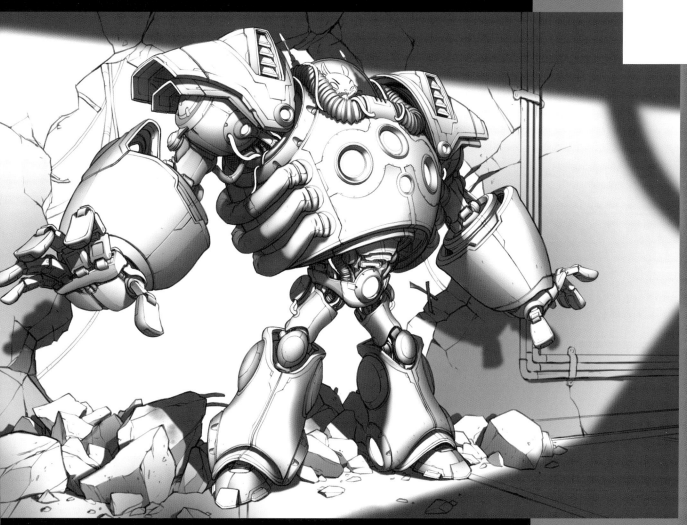

This page (top): Adding the shadow and base highlight layer rounds out the forms

This page (bottom): Reflections and lights define how the character is reacting to the world around it

Opposite page: Rim lighting can help to add further volume and enhance the silhouette

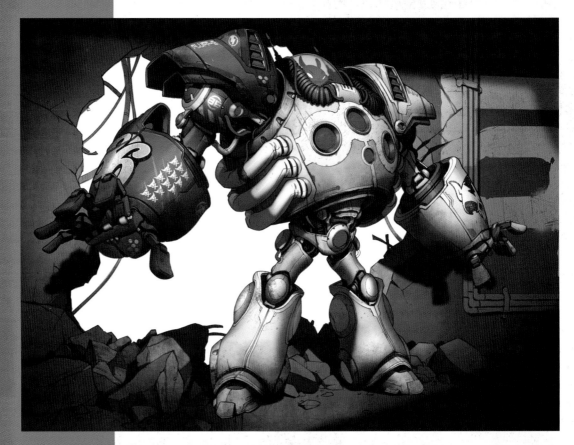

APPLYING SHADING AND BASE HIGHLIGHTS

The basic ambient light color is reflected into the shadows, so I like to tint the shadows accordingly before setting them to Multiply over the color layers. This tends to make the shadows look less muddy. I then turn my focus to the highlights with an initial subtle pass where the lit areas of the forms are brightened up using either Overlay or Add layer modes. At this point, the design has everything required to be a useful concept – but let's bring it to life.

LIGHTS AND REFLECTIONS

Adding reflections to the various shiny elements helps to show how the character's surfaces are reacting to the world around them. It also helps to distinguish how rough each surface is. I like to make sure there is a balanced amount of highly reflective and less reflective surfaces, like rubber and matte paint, to add visual variety. Adding glows to the lights and cables that are intended to be lit adds a lot of energy to the character, even though it's just a static pose.

RIM LIGHTING

With my designs I like to use a rim light or back light to help emphasize the volumes and silhouette that have become obscured by the primary light angle. In this instance, a brightly lit hole in the wall is doing the job. This light allows me to identify obscured parts, like the distant arm and leg, and plausibly enhances the form's readability. It also adds a nice level of drama depending on how it's used. Keep this in mind the next time you find yourself having just broken through a meter-thick concrete wall if you want to look cool doing it.

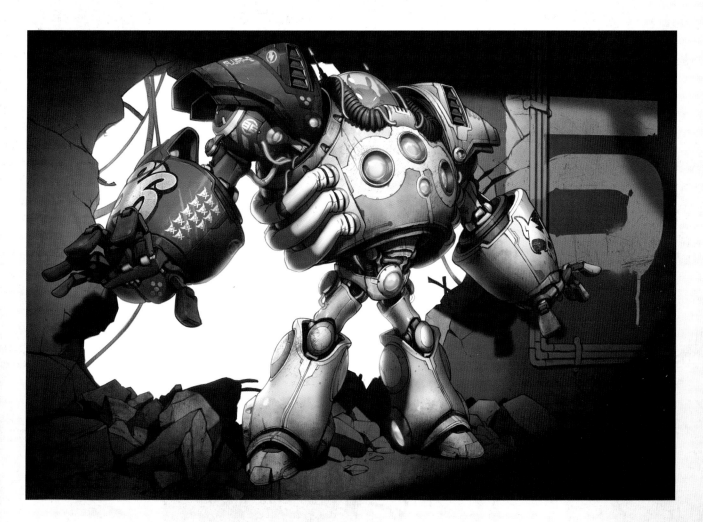

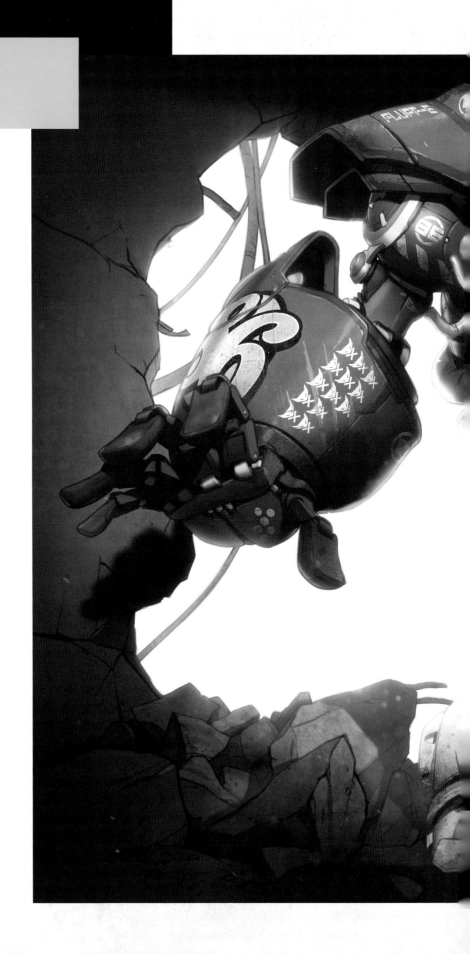

"BY USING SUBTLE EFFECTS LIKE FOG, FLOATING DUST, AND SOME GENTLE COLOR OVERLAYS THAT BRING COHESION TO THE ENTIRE DESIGN, THE CHARACTER AND ENVIRONMENT ALL BECOME UNIFIED"

ADDING ATMOSPHERE

The last step is to tie the whole piece together using a bit of atmosphere. Every previous step has been about creating a sense of believability for each individual part of the design. By using subtle effects like fog, floating dust, and some gentle color overlays that bring cohesion to the entire design, the character and environment all become unified. And with that, this little escapee is free to explore the world in the safety of his newly acquired battle mech. Safe travels, and don't forget to charge those batteries!

These pages: Use atmosphere to unify all the disparate elements into a cohesive design

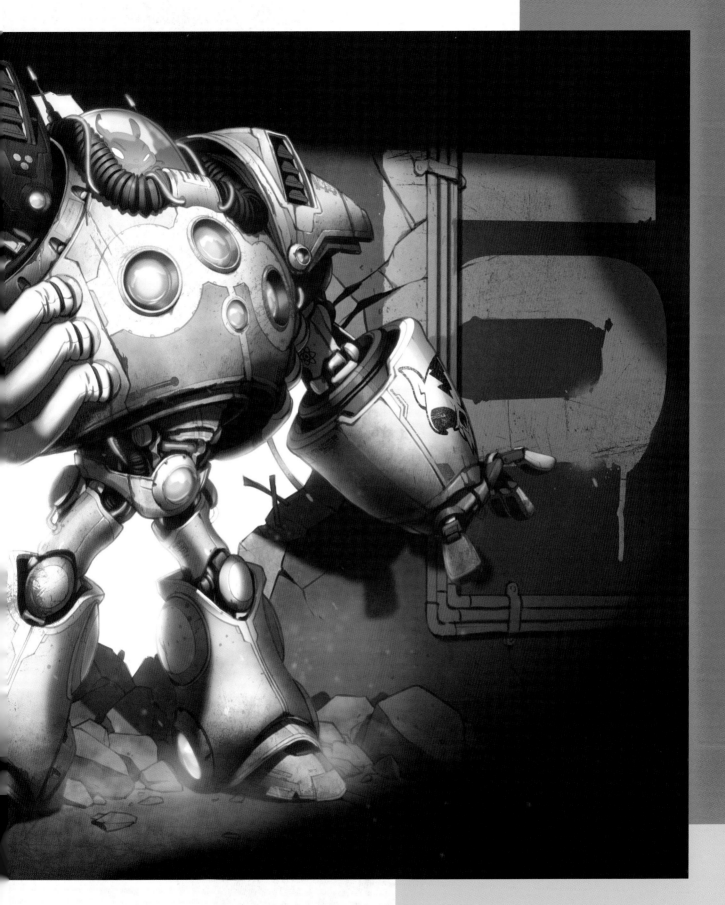

CONTRIBUTORS

ALEXIS AUSTIN

Freelance Character Designer

lexiarts.com

After studying clinical psychology, Alexis switched careers to pursue her passion. She currently works in the indie animation space in Los Angeles.

GREG BALDWIN

Head of Studio at Lost Bear Studios

lostbearstudios.com

After 20 years as a principal character artist in the AAA gaming space, Greg launched Lost Bear Studios, working with Disney, Bad Robot, and more.

TOM BANCROFT

Pencilish Animation Studios, CEO

pencilish.com

Tom is a former supervising animator at Disney, character designer, instructor, illustrator, and is the founder and CEO of Pencilish Animation Studios.

JACKIE DROUJKO

Character Designer, Netflix

jackiedroujko.com

Jackie is a character designer at Netflix and creates films in her spare time. She creates simple, appealing designs that tell compelling stories.

MAX GRECKE

Freelance Illustrator/ Concept Artist

instagram.com/maxgrecke

Max Grecke is a freelance character artist. His work has featured in games such as *Hearthstone* and *League of Legends*.

EIRINI MICHAILIDOU

Character Designer & 2D Artist

instagram.com/eirinimic

Eirini is a Greek designer based in Ireland. She works as a character designer and 2D artist in animation and mobile games.

EDDY OKBA

Animator at Pixar Animation Studios

eddyokba.com

Eddy Okba is a character animator who has worked on several feature films, such as *Spider-Man: Into the Spider-Verse* and *Lightyear*.

JOAKIM REDINGER

Lead Animator

jouak.com

Joakim is an Annie Awards nominee, and has worked on several feature films. He is currently lead animator on HBO's *House of the Dragon*.

DANIEL TAL

Storyboard Artist at Dreamworks Animation

instagram.com/daniel.m.tal

Since graduating from Sheridan college in 2016, Daniel has worked on TV shows and feature films, such as *Trolls 2* and *Abominable*.

MELANIE PEÑALOZA TIKHONOVA

Student

melanamobes.com

Melanie is a character designer whose work is inspired by her love of shapes, colors, fashion, and the people she meets.

STICK FIGURES
BY LORENZO ETHERINGTON

GIVE YOUR STICK FIGURES **THREE DIMENSIONS** BY SIMPLY USING A **LINE BREAK** ON ANY LIMBS WHICH FALL *BEHIND* OTHER PARTS OF THE BODY.

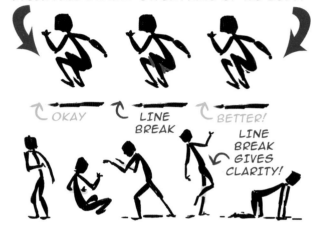

OKAY *LINE BREAK* *BETTER!*

LINE BREAK GIVES CLARITY!

BECAUSE STICK FIGURES ARE SO **SIMPLE,** THEY'RE VERY EFFICIENT AT CAPTURING THE *ESSENCE* OF A POSE.

BY NOT ADDING CLOTHING, FACIAL EXPRESSIONS OR CONTEXT, WE CONCENTRATE ON BODY LANGUAGE ALONE

FIGURES THAT HAVE **LEFT THE GROUND** CAST *SHADOWS!*

HOW HIGH?

THE CORE OF ANY POSE IS **BALANCE** (OR A LACK OF IT!). WE CAN ESTABLISH THE **DISTRIBUTION OF BALANCED WEIGHT** USING A *PLUMB LINE.*

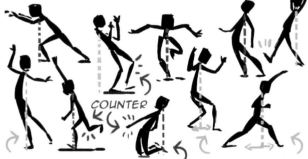

COUNTER

STICK FIGURES ARE A GOOD GROUNDING FOR *GESTURE DRAWING* AND *LINE OF ACTION!*

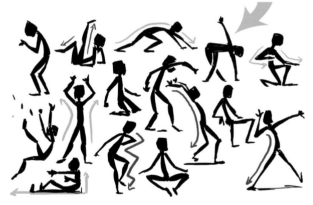

PLUMB LINE RUNS FROM THE BASE OF THE NECK DOWN TO WHICHEVER LIMB(S) SUPPORT THE WEIGHT

THE FURTHER THE CENTRE OF BALANCE IS OUT, THE MORE THE BODY HAS TO COMPENSATE

IF WEIGHT IS DISTRIBUTED BETWEEN LIMBS, PLUMB LINE FALLS DOWN BETWEEN LIMBS